GLADIATOR GAMES

A dramatisation of the events surrounding the death in custody of Zahid Mubarek in Feltham Young Offenders Institute in March 2000.

With verbatim text from evidence given to the Zahid Mubarek Inquiry and interviews.

Tanika Gupta

GLADIATOR GAMES

OBERON BOOKS
LONDON

WWW.OBERONBOOKS.COM

First published in 2005 by Oberon Books Ltd
Electronic edition published in 2012

Oberon Books Ltd
521 Caledonian Road, London N7 9RH
Tel: +44 (0) 20 7607 3637 / Fax: +44 (0) 20 7607 3629
e-mail: info@oberonbooks.com
www.oberonbooks.com

Second edition, 2006

A catalogue record for this book is available from the British Library.

PB ISBN: 978-1-84002-624-5
E ISBN: 978-1-84943-858-2

Cover design by Luke Wakeman

eBook conversion by Replika Press PVT Ltd, India.

Visit www.oberonbooks.com to read more about all our books and to buy them. You will also find features, author interviews and news of any author events, and you can sign up for e-newsletters so that you're always first to hear about our new releases.

Foreword

I remember reading about the horrific racist murder of Zahid Mubarek in the papers a few years back. I recall seeing a picture of his handsome, youthful face and the tattooed but equally youthful face of his murderer Robert Stewart. The story affected me, and the fact that Zahid was an Asian youth serving a sentence for minor offences was not lost on me. Beyond my initial reaction, I'm afraid the story slid back into the recesses of my mind.

Over the following years I worked on a project with Clean Break and spent some time in HMP Winchester running writing workshops for the female inmates. I had never stepped inside a prison before then and the research for the play I subsequently wrote for Clean Break also took me to HMP Holloway. I kept thinking: 'There but for the grace of God go I'. The inmates that I met were for the most part women who had lost their way and turned to crime, who through poverty, lack of education, family trauma, broken homes, lack of opportunities, bad legal representation or simply through getting in with the wrong company, had ended up in prison. In HMP Winchester, my writing group of fifteen women were mainly black, mixed-race or foreign nationals, and all of them were desperate to change, to live better, more productive lives once they were back on the outside. Some of them were serving disproportionately long sentences for seemingly minor offences. Education was virtually non-existent, the prison library had very little reading material except for soft porn and the odd Jane Austen novel, and some of the prison officers seemed to resent the women having opportunities to educate themselves. After I'd finished my writing workshop, the group hand-made me the most beautiful card and each signed their names writing at the end 'remember me'.

When the director Charlie Westenra approached me to write about Zahid Mubarek, the same questions I had asked before came back. Does prison work? What are we doing as a society when we are sending children and young people to prisons

without giving them the means to change, to educate themselves, to rehabilitate? In interviews with Zahid's uncle Imtiaz, he brought up this very question – saying that, surprisingly, during the whole Zahid Mubarek Inquiry, there was hardly any mention of the word 'rehabilitate'. In my interview with Colin Moses, Chair of the Prison Officers' Association, he pointed out that UK inmates don't have the right to vote, which meant that as far as Governments were concerned, it was a proportion of society that didn't need to be represented. Who cares about prisoners as long as they are 'safe behind bars', away from the community, unable to harm law-abiding citizens? Money was supposedly better spent on public services such as hospitals and schools. But Moses added that we forget that prisons are also a public service.

As I worked through the vast piles of evidence from witnesses for the Zahid Mubarek Inquiry and looked at the way prison had failed to protect Zahid or keep him 'safe behind bars', the systematic failures of the Prison Service at every level were astounding. The incredible story of Robert Stewart's long-standing mental illness which was never addressed or recognised, his racist views and his long history of self-harm tell another story of a young man who has also been failed by society. It is easy to say that this is liberal posturing but one has to try and work out how we deal with the Stewarts of this world. He said of himself to the Commission for Racial Equality:

'Somebody should have thought I was a time bomb waiting to explode'.

In his various Chief Inspectorate reports on Feltham, Sir David Ramsbotham wrote:

'Feltham contains what my very experienced Chief Medical Inspector described as the most seriously mentally disturbed group of young men he has come across in his career, the majority of whom should be in medical rather than custodial accommodation. This report is without doubt the most disturbing that I have had to make during my three years as HM Inspectorate of prisons. I have to disclose to the public...that conditions and treatment, of the 922 children and young prisoners...are in many instances totally unacceptable...'

Beyond the obvious mental illness, however, were the chillingly racist letters written by Stewart from his various prison cells. The fact that these went unnoticed and unmonitored by the Prison Service has prompted many to question whether prisons are safe for black inmates.

Zahid Mubarek came from a strong, loving and close-knit family, and whilst they were shocked at the harshness of Zahid's sentence they hoped that a short spell in prison would help him see the error of his ways. Indeed, his letters to his family show a young man who was keen to move away from petty crime. The way in which Zahid died was horrific beyond belief but the family kept asking: 'How did this happen?' They had to fight for four and a half years to persuade the Government to conduct a Public Inquiry into Zahid's death and the-then Home Secretary, David Blunkett, refused to meet or speak to them. The Law Lords forced Blunkett's hand and the family won their quest – although, sadly, the question of sentencing was left outside the remit of the Inquiry. Whilst the family's bravery and determination is astonishing, what I did see through meeting them was a broken-hearted family still grappling with their grief. As a parent myself, I can't imagine how you move on from the terrible death of a child, but the Mubarek family's doggedness to hold the Prison Service accountable and open to scrutiny is matched only by Stephen Lawrence's family's determination to expose institutional racism in the Metropolitan Police Service. Regardless of the recommendations of the Zahid Mubarek Inquiry, it seems obvious to me that institutional racism exists in the Prison Service and as such, by exposing it, the Mubarek family have done us all a favour. Who can say with complete certainty that it won't be their son or daughter forced to share a cell with a Robert Stewart in the future?

<div align="right">Tanika Gupta
September 2005</div>

I'd like to thank the following people for their help and support in writing this play: Colin Moses; Suresh Grover; Imtiaz Amin; Amin Mubarek and Sajida Mubarek; Imran Khan.

Timeline of events

23 October 1980 Zahid Mubarek born at Whipps Cross Hospital, London.

17 January 2000 Zahid is sent to Feltham Young Offenders' Institute after being found guilty of stealing razors and interfering with a motor vehicle.

8 February 2000 Robert Stewart, a prolific offender from the Manchester area, is moved into the same cell as Zahid. Stewart's odd behaviour is noted by other inmates.

21 March 2000 Hours before Zahid's release, Stewart batters him with a table leg as he sleeps. Stewart then presses the cell alarm button.

28 March 2000 Seven days later, Zahid dies in hospital from his injuries. Stewart is charged with his murder.

November 2000 Stewart is found guilty of murder and sentenced to life. He is found to be a psychopath and the trial uncovers evidence of his racist tendencies. Three weeks after his jailing, the Commission for Racial Equality announces it will hold its own investigation into the events.

4 September 2001 The family go to the High Court to force the Home Secretary, David Blunkett, to hold an independent public inquiry. Mr Justice Hooper agrees with the family, saying David Blunkett has failed in his duty to take into account his obligations under the Human Rights Act.

March 2002 The Court of Appeal throws out the earlier decision, siding with the Home Secretary. The judges say there is no need under Human Rights law to hold an inquiry because it has been proven the Prison Service has been at fault, an internal inquiry has investigated and Robert Stewart has been jailed for the murder.

October 2002	The prisons watchdog sends a team inside Feltham. It concludes that the jail had fundamentally changed and was 'off the critical list'.
July 2003	The CRE publishes its report into Zahid's death, amid criticism over its conclusions and the time taken to reach them. CRE chairman Trevor Phillips says he is convinced Zahid would not have died had he been white. The report says there was a 'shocking catalogue of failure' within the Prison Service. The family reject the report, saying it is flawed and leaves them none the wiser as to why Zahid was sharing a cell with Stewart.
October 2003	The family turn to the House of Lords. Lord Bingham, sitting with Lords Slynn, Steyn, Hope and Hutton, overturns the Court of Appeal and sides with the family. They order the Home Secretary to hold an Inquiry.
28 April 2004	David Blunkett announces 'The Zahid Mubarek Inquiry'.
30 August 2004	The Inquiry begins. Phase One investigates the events leading up to Zahid Mubarek's death.
April 2005	Closing submissions, Phase One.
19 September 2005	Phase Two of the Inquiry begins. It holds the first of six seminars. The events will help chairman, Mr Justice Keith, to assess what recommendations he should make to the Home Secretary to minimise the chances of a tragedy such as Zahid's murder happening again.
5 October 2005	Phase Two of the Inquiry ends.

Mr Justice Keith hopes to deliver his report to the Home Secretary in April 2006.

(Sources: BBC, Monitoring Group, The Zahid Mubarek Inquiry)

This play is dedicated to the memory of Zahid Mubarek

Gladiator Games had its World Premiere performed at the Crucible Studio from 20–29 October 2005; then performed at Theatre Royal Stratford East from 2–12 November 2005.

Restaged at Theatre Royal Stratford East from 2–25 February 2006.

Cast in order of speaking:

IMTIAZ AMIN, ZAHID MUBAREK	Ray Panthaki
ROBERT STEWART, DUNCAN KEYS	Kevin Trainor
MAURICE TRAVIS, JAMIE BARNES	Paul Keating
MUBAREK AMIN, SURESH GROVER	Shiv Grewal
SAJIDA MUBAREK, SATWANT RANDHAWA	Claire Lichie

All other parts played by members of the company

Writer	Tanika Gupta
Director	Charlotte Westenra
Designer	Paul Wills
Lighting Designer	Hartley T A Kemp
Composer	Niraj Chag
Sound Designer	Nick Greenhill
Casting	Leila Bertrand
Assistant Director	Zahra Ahmadi
Dialect Coach	Jeannette Nelson
Fight Director	Bret Yount
Production photographer	Johann Persson

For Sheffield Theatres:

Stage Manager	Donna Reeves
Deputy Stage Manager	Helena Lane-Smith
Assistant Stage Manager	Julie Davis

For Theatre Royal Stratford East:

Stage Manager	Julia Crammer
Deputy Stage Manager	Altan Reyman
Assistant Stage Manager	Rebecca Clatworthy

Characters

ZAHID MUBAREK

AMIN, his father

SAJIDA, his mother

IMTIAZ, his uncle

MARTIN NAREY, Director General, HM Prison Service

COLIN MOSES, Chair, Prison Officers' Association

DUNCAN KEYS, Assistant Secretary, POA

NIGEL HERRING, Branch Chairman, POA

STEVEN MARTINDALE, Feltham prison officer

DEBBIE HOGG, Feltham prison officer

IAN MORSE, Feltham prison officer

STEPHEN SKINNER, Feltham prison officer

MALCOLM NICHOLSON, Feltham prison officer

SATWANT RANDHAWA, Feltham prison officer

ROBERT STEWART, prisoner

MAURICE TRAVIS, prisoner

JAMIE BARNES, prisoner

JUSTICE KEITH, Judge at Inquiry

DEXTER DIAS, barrister at Inquiry

NIGEL GIFFIN, barrister at Inquiry

PADDY O'CONNOR, barrister at Inquiry

SURESH GROVER, Monitoring Group, Institute of
Race Relations

PROFESSOR GUNN, Institute of Psychiatry, KCL

LUCY BOGUE, Independent Monitoring Board, Feltham

JUDY CLEMENTS, Race Equality Adviser,
HM Prison Service

DOCTOR, PRISON OFFICERS, INMATES, POLICE OFFICERS,
SPOKESPEOPLE

List of sources

1 Verbatim evidence from the Zahid Mubarek Inquiry
 – witness statements, oral and written **[V1]**
 The Inquiry includes evidence from:

 a MPS – Metropolitan Police Service **[V1a]**

 b Butt Inquiry/Feltham Murder Report **[V1b]**

 c Closing statements **[V1c]**

2 Interview – three taped interviews taken with:

 a Imtiaz Amin and Suresh Grover at the
 Monitoring Group, Institute of Race Relations **[V2a]**

 b Colin Moses, Chair of the Prison Officers'
 Association **[V2b]**

 c Sajida Mubarek and Mubarek Amin (Zahid's parents)
 at their home in Walthamstow **[V2c]**

3 Channel 4 documentary: 'Prison Works: the death of
 Zahid Mubarek' **[V3]**

4 *Panorama* documentary, BBC: 'Boys Behind Bars' **[V4]**

5 CRE (Commission for Racial Equality) Inquiry:
 witness statements **[V5]**

6 Correspondence:

 a Zahid Mubarek's letters from Feltham **[V6a]**

 b Robert Stewart's letters from prison **[V6b]**

 c Letters to the Mubarek family **[V6c]**

7 'Colour Bar' leaflet **[V7]**

8 Justice Hooper's judgement **[V8]**

9 Justice Bingham's statement **[V9]**

Verbatim text reproduced from these sources is marked with an asterisk in square brackets [*]; the references are given at the end of the reproduced text in the form shown above ([**V1a**], [**V3**], etc).

Anything unmarked is a dramatisation based on events / hearsay.

Act One

SCENE 1

An Asian man in his mid-thirties – IMTIAZ – steps forward and addresses the audience.

IMTIAZ: My name's Imtiaz Amin, Zahid was my eldest brother's son.

[*] I'm ten years older than Zahid. There were lots of things we had in common – like cricket, certain music, dare I say it 'gangsta rap'. Zahid used to play regularly at Vestry Park round the corner from where we live. A group of him and some lads used to congregate there regularly. Start playing with a tennis ball and cricket bat. He was very close to his cousins and had a group of friends. He was very athletic. He did a year on this Prince's Trust army training thing. It was a confidence-building thing. It was just to gear people up for work, people who may suffer from, erm – low esteem, motivational problems – whatever. And it was very military orientated. Zahid wanted to go into the army. He also used to help his dad working on his car – doing up the Cosworth – loved that car he did.

He had a sense of humour, always joking with us – made us smile.

But he got into trouble. Ended up serving a short custodial sentence of ninety days at Feltham for stealing six pounds' worth of razor blades and interfering with a car. Nobody understood why he got sent down for what he did. It was, it was a shock. [V2a]

Two BARRISTERS step forward.

DIAS: [*] Dias. Closing Submissions on behalf of the Mubarek family.

It is absolutely true that no one could have forecast with mathematical certainty that on 20th March 2000 Robert Stewart would club to death Zahid in cell 38 at Feltham, Swallow Wing. But how far does this truly absolve the prison service, especially when one considers the obvious risks that Stewart presented? **[V1c]**

GIFFIN: [*] Giffin – Counsel for the Zahid Mubarek Inquiry. Closing statements.

I pose the question: a disaster waiting to happen or a prisoner who did not stand out? There seems to have been a radical disconnection between the perception of Stewart and the risks which he posed. The submissions which the Prison Service now makes to you come very close indeed to saying that in terms of handling, nothing really went wrong in this case and Zahid's murder was a dreadful but essentially random occurrence. **[V1c]**

DIAS: [*] In simple terms, what do we think might happen when we lock up a dangerous, severely mentally disordered, psychopathic racist in a cell for 20-plus hours with a young Asian who is in prison for the first time? The opportunities to avert this tragedy lie scattered across the prison records and in the collective knowledge of Stewart that the Prison Service had gained over his criminal career. **[V1c]**

GIFFIN: [*] There is, I think, for the Mubarek family at the end of these hearings no simple answer to the question: 'How did this happen?' There are questions as to whether some witnesses have told the truth to this Inquiry.

You will also have to decide how far the question of racial discrimination and the effectiveness or ineffectiveness of the Prison Service and of Feltham in dealing with racism at this time enters into the equation. I suggest, for my part, that it is impossible not to conclude that there were very serious problems on a greater scale, certainly at Feltham, than anyone had succeeded in identifying before Zahid was killed.

What price is society prepared to pay in terms of how many people it sends to prison and what resources it provides to the Prison Service in order to avoid future occurrences of this kind? [V1c]

DIAS: [*] Sir, ultimately this Inquiry documents the story of two young men from different backgrounds, one white and one Asian. They were both born in 1980 and because of the deep-seated failures in our prison system, they were locked together behind the door of cell 38 at Feltham. On a March night in 2000, Robert Stewart, who was known to the Prison Service to be violent, dangerous and a racist, clubbed Zahid to death with a table leg while Zahid slept. The family want to say that the murder of Zahid Mubarek was a terrible injustice. His family believes that it is one which in differing ways affects us all. As Dr Martin Luther King once wrote from a cell in another prison: 'Injustice anywhere is a threat for justice everywhere. We are caught in an inescapable network of mutuality tied in a single garment of destiny. What affects one directly affects all indirectly.' This was a murder that could and should have been prevented. As such, it is part of the story of our troubled times. [V1c]

SCENE 2

Sounds of a busy hospital as lights go up. We see a body on a stretcher being brought in (we cannot see the face but just see a shape beneath the sheets). A doctor and a nurse busy themselves working on the patient: a drip is set up, etc.

An Asian man (AMIN) and woman (SAJIDA) stand by and watch helplessly. SAJIDA is weeping continuously but not making any noise. A younger Asian man (IMTIAZ) enters. He looks equally distraught. AMIN and SAJIDA approach him. The two men embrace briefly.

IMTIAZ: *(East London accent.)* How is he?

AMIN: *(East London accent.)* He's just come out of the operating theatre. He's still unconscious.

IMTIAZ: How long have you been here?

AMIN: We waited over an hour before they brought him here.

IMTIAZ: Why'd it take them so long to get here?

AMIN: I dunno. Something about them going to another hospital...Ashford...that's what they said...when they first phoned. Then, they came round...the Police...gave us an escort and said they were bringing him here. We were waitin' and waitin'.

He looks...he looks...they said there'd been a fight in the cell.

IMTIAZ: Did he speak?

SAJIDA: *(Pakistani accent.)* His face.

IMTIAZ: Amin, did he speak?

AMIN: How can he speak? He's unconscious.

IMTIAZ looks upset.

SAJIDA: *(In Punjabi.)* What happened, Imtiaz?

IMTIAZ: I phoned the prison. Phoned loads. Kept me waiting...kept passing me on to someone else. No one knew anything. Eventually spoke to the Governor number two. Said he didn't know what happened, first he said there'd been a fight, then he said something about that Zahid'd been attacked by his cellmate – probably through jealousy.

AMIN: Jealousy?

IMTIAZ: 'Cos Zahid was being released today.

SAJIDA: How could this happen? I don't understand.

IMTIAZ: He's in a bad way?

AMIN nods.

He's gonna make it though – right?

AMIN looks at SAJIDA anxiously.

AMIN: His head looks…swollen…like a huge balloon. Three times the normal size. Face is full of blood – bruises all over it…

SAJIDA: He's just a boy.

Beat.

IMTIAZ: Anyone from the Police here? The prison?

AMIN: A policeman was here…didn't tell me nuthin' though.

SAJIDA: Just a few more hours…he would've been home.

AMIN: He was so happy, last time I saw him, at the last visit, you know? He was so excited that he was getting out.

SAJIDA: We have to pray for him.

SAJIDA starts to cry more. AMIN and IMTIAZ watch her helplessly. AMIN takes IMTIAZ aside, away from SAJIDA.

AMIN: Go and see him Imtiaz. See for yourself.

IMTIAZ: What do the doctors say?

AMIN shakes his head.

AMIN: Is my boy gonna… For what? Why?

AMIN breaks down. IMTIAZ looks distraught. He helps his brother back into the chair. He watches SAJIDA and AMIN for a moment as he sits next to them. The hospital is still busy with people rushing around.

They're supposed to be safe in prison. They're supposed to look after 'em. He's just a kid. Why Zahid? Why'd this happen to him? He's a good lad…never got into fights before…

A DOCTOR comes forward.

DOCTOR: Mr and Mrs Mubarek, would you like to come through now?

As SAJIDA and AMIN follow the DOCTOR to ZAHID's bedside, IMTIAZ steps forward and addresses the audience.

IMTIAZ: By the time I got to the hospital that morning of the 21st they'd already operated on Zahid. And – he was just unconscious, lying down – they had him there naked. One quandary was that here was this perfectly formed man here. But you just looked at his head and it was just horrendous. You know. He was in intensive care for seven days. His skull had been cracked in several places. He had these holes and these pipes coming out – kind of fluid stuff coming out. You couldn't imagine that someone in that condition could survive.

IMTIAZ looks back at AMIN and SAJIDA.

[*] Anyway, we were at the hospital, yeah, for the next seven days, basically hoping for some sort of a recovery. It was very disheartening. It was every emotion you can think of, you just went through anger, you wanted to cry, you wanted to hug him.

After three days people from the prison came to the hospital. They included the Muslim adviser and Martin Narey who was the Director General of the Prison Service. **[V2a]**

MARTIN NAREY enters. He approaches AMIN and SAJIDA.

NAREY: *(Posh Northern.)* Mr Mubarek?

AMIN looks up.

Martin Narey.

NAREY puts his hand out to AMIN. AMIN hesitates before taking it.

How is Zahid doing? Have the doctors spoken to you?

AMIN: Yes. The prognosis isn't good.

NAREY looks upset. AMIN stares blankly at NAREY.

What 'appened in that cell?

NAREY: I don't honestly know.

AMIN: Was there a fight?

NAREY: We're not sure.

AMIN: He was so excited about coming home. He was being released later this morning.

NAREY: Yes...

AMIN: Who was this cellmate?

NAREY: I'm afraid I don't have any more information...

It's a Police investigation now and they're doing everything they can to get a clear picture of events.

AMIN turns away.

[*] You had a right to expect us to look after Zahid safely and we have failed. I am very, very sorry. [V6c]

AMIN: 'Sorry' doesn't come into it, does it?

AMIN exits, leaving NAREY looking after him anxiously. SAJIDA never even looks up.

IMTIAZ: [*] We didn't really appreciate Martin Narey's visit. We just wanted to know if our nephew or son was going to make it through.

I was just running around trying to find some kind of representation. I was just really angry that something like this happened, you know what I mean? I was particularly pissed off that something like this could happen in a prison and I wanted it to be highlighted. It could be anyone's kid. And this is what prisons are like. It was a real shock for us. A solicitor friend of mine gave me the web-link for the Institute of Race Relations. I was looking at the web for that and there was a link to the Monitoring Group from

that and I just got in touch with them and Suresh Grover came to the hospital. **[V2a]**

SURESH enters.

SURESH: [*] *(Indian accent.)* I met Imi before Zahid died. There was a lot of anxiety in the family. Firstly would Zahid survive? Secondly how did he end up in this situation? Thirdly – who would be held responsible? **[V2a]**

IMTIAZ: [*] We kept asking these questions which no one would – like – no one could answer. There was this thing about this...prison adviser, which was that he was actually leaking some information to us regarding this individual who had done this crime. It was him who first told us that this guy – Stewart – Zahid's cellmate had been – has got a history – of violence – and that he's done this to other people before. Later on you know they wanted to go for an out-of-court settlement – which we outright refused. **[V2a]**

SURESH: [*] Let's put it this way, it wasn't the prison service that offered. The adviser was told to approach the family to tell them to take some money and forget about it. That's what the adviser said to Imtiaz.

IMTIAZ: Yeah.

SURESH: It's as blunt as that. I think you are being polite. The adviser said to the family, why are you doing this? You could get a lot of money – take the money. We never kept in contact with him after that. Why was he doing that? It isn't his job. He shouldn't be put in that position. After the attack there was nobody there from the prison service whatsoever. **[V2a]**

IMTIAZ: [*] The Imam from the prison – he visited. He wasn't there officially. He was actually giving us some information as well. He was telling us about – this individual – Stewart, Zahid's cellmate – and about the regime and the failings about what was going on there and stuff. It was then that

we started to get this picture that it was bigger than Robert Stewart. Two main things for us were not only Robert Stewart – his record – but the negligence caused by the prison officers. **[V2a]**

SAJIDA enters.

SAJIDA: [*] We'd been at the hospital all day, we came home at about 11.30 in the evening – had a phone call at about one and when we got there, he'd already died. That was exactly a week after he'd got to the hospital. **[V3]**

The DOCTOR pulls a sheet over ZAHID's body.

SURESH: [*] The family wanted the body of Zahid quite quickly after his death – for religious purposes – but in order to convict the person they needed the brain so we were negotiating. In the end we agreed that the body could be released without the brain. The brain had to be analysed for another six weeks. **[V2a]**

We hear the unmistakable sound of a life support machine's beep. ZAHID's body is wheeled out.

MARTIN NAREY re-enters and approaches IMTIAZ. IMTIAZ is lost in thought for a moment while NAREY stands awkwardly. Eventually IMTIAZ looks up at NAREY.

NAREY: Mr Amin…

IMTIAZ: Yes?

NAREY: I was thinking of planting a tree…in honour of Zahid's memory…in the grounds of Feltham.

IMTIAZ looks at NAREY, incredulous.

IMTIAZ: I'd rather you flattened the place.

NAREY looks uncertain and exits.

A few days after Zahid's death DCI McLeenan…

SURESH: The guy who interviewed Stewart…

IMTIAZ: Yes…he showed us these letters that Stewart had written in prison. There was this one in particular that he'd written a month before Zahid was attacked.

IMTIAZ reads STEWART's letter.

IMTIAZ: [*] '23RD FEB 2000

CANNOT SEE IT STICKIN' IN ERE.

IF I DON'T GET BAIL ON THE 5TH, I'LL TAKE XTREME MEASURE TO GET SHIPPED OUT, KILL ME FUCKIN' PADMATE IF I HAVE TO; BLEACH ME SHEETS AND PILLOWCASE WHITE AND MAKE A KLU KLUX KLAN OUTFIT AND WALK OUT ME PAD WIV A FLAMING CRUCIFIX AND CHANGE THE CROSS ON MY HEAD TO A PLUS AND THEN A SWASTIKA WIV A BIRO.

…SIGNED STEPHAN LAWRENCE.' **[V6b]**

It was disgusting. I mean, I've experienced petty racism all through my life but this…this was on another level. I felt angry at Stewart – I mean you're getting an insight into someone's mind and you don't wanna be there.

SURESH: That was the moment for me. When I first met Imi, we didn't talk about racism. It didn't even occur to us that this was a racist attack.

IMTIAZ: No, not at all. Not at all. But Stewart's letters changed all that. I couldn't understand how someone could kill Zahid for the colour of his…bloody skin.

IMTIAZ exits.

SURESH steps forward.

SURESH: [*] Not many people would go through a death in a prison, come across the person who murdered their son, totally psychotic… I mean we saw Stewart at the murder trial. He was giving 'V' signs to the father and Imtiaz and everybody, shouting at the jury members, he was

absolutely barmy. His defence was that he's so racist he didn't know what he was doing. You don't come across those kind of things. It's one of the few times when I've sat in a court and thought, 'My God what am I doing in this country?' You fight on the Lawrence case, you think there's a sea change in this kind of attitude and then you see something like that, someone like Stewart. And you think your whole energy and time has been wasted. And he has no remorse about the thing. He has no respect for the family. Okay, you killed the person because of whatever but you don't have to be extravagant in killing someone and radiating your racism. This is what he did.

STEWART enters.

In November 2000 – Robert Stewart was found guilty of murder and was sentenced to life. On the same day, we launched the campaign to get a Public Inquiry into the death of Zahid Mubarek. **[V2a]**

SCENE 3

TRAVIS: [*] *(Manchester accent.)* Maurice Travis. I've known Robert for about eight years, we met in a care home when I was about twelve; he's slightly younger than me…we're good mates and still contact each other by letter now. We started committing crime together, all sorts and got locked up together. I would say he follows me, it's like he worships everything I do, he does. **[V5]**

We see STEWART and TRAVIS sat in a cell together. They are laughing and talking together in whispers.

Go on, I dare you, fuckin' wimp.

STEWART: Fuck off Trav.

TRAVIS: Go on, it'll be a laugh. You got the matches. Do it.

STEWART: What's in it for me?

TRAVIS: I'll give you a few burns.

STEWART: How many?

TRAVIS: Four.

STEWART giggles.

PROFESSOR GUNN steps forward.

GUNN: [*] My name is Professor Gunn. I am the Emeritus Professor of Forensic Psychiatry at the Institute of Psychiatry, Kings College London. My work has included research into the mental health and psychiatric needs of prisoners. I'll follow the set of questions set out in writing to me.

Robert Stewart was born on 4th August 1980 and is a recidivist with (in 1999) 18 convictions and 65 offences to his name, including two offences against the person, six offences against property and 45 theft offences. Two of the property offences were for arson. He had by the year 2000 served six prison sentences. **[V1]**

We see STEWART striking a match and setting fire to something.

TRAVIS: Fuckin' ace.

GUNN: [*] Dr Nayani who was instructed by Robert Stewart's defence solicitor concludes: 'the defendant suffers with severe personality disorder. Mr Stewart is a psychopath.'

Robert Stewart told Dr Shapero that he was expelled from a secondary school at the beginning of the second year after setting the sports hall on fire 'for fun'. He did not receive home tuition. He was found a placement at the beginning of the third year of secondary school but 'never went' and only attended 60 days out of 190. At the end of his third senior academic year, Mr Stewart was suspended from school and taken into local authority care. By this time he was 'getting into trouble all the time'. **[V1]**

PRISON OFFICER: *(Offstage.)* Open cell 25.

The two boys watch the fire as it gains strength – mesmerised (lots of smoke). The smoke fills the stage and the two boys leap around the cell yelping and shouting and laughing. We hear an alarm go off and shouting off stage. The fire is quickly put out by a PRISON OFFICER.

PRISON OFFICER: What the hell d'you think you're playing at?

STEWART is giggling.

It ain't funny! You could have hurt yourselves.

STEWART: Just did it for a laugh, guv.

PRISON OFFICER: Whose idea was this? Yours, Travis, I'll warrant.

TRAVIS: Yeah – thought we might burn this place down to the ground.

PRISON OFFICER: Clear this mess up now. I'm giving you a direct order. Clear it up. Out, Travis. See what the Governor has to say about this. You're both on report and segregation.

TRAVIS is led away.

GUNN: [*] Here are some salient events from Mr Stewart's record which suggest mental disturbance.

20th August 1997, flooding cell deliberately; recurrent self-injury; hearing voices come from anywhere.

25th September 1997, RS 'refuses to speak or engage in any form of conversation. I feel this inmate will do harm if removed from strict conditions.' **[V1]**

STEWART sits on his bed and stares weirdly at the audience.

[*] October 1997, it was noted that he exhibited 'bizarre behaviour on wing. Suggest hospitalisation for assessment.' He was admitted to the health centre. He said he felt odd compulsive actions. The nurse noted 'spoke with Stewart about compulsive actions. Whilst denying hearing voices,

feels he must carry out whatever action he feels to do. This happens during quiet periods.'

26th October 1997, relocated in a strip cell having smeared excrement on his wall, covered himself in margarine and flooded his cell. **[V1]**

STEWART ties lots of bits of clothes to himself.

STEWART stands in his cell and screams gobbledygook at the top of his voice. The screaming goes on for a while. Then he sits down again.

[*] November 1997, he was found to be incommunicative: 'all he can say for himself is "I don't know"'.

21st November 1997, it was noted 'RS behaving strangely, eating soap and swallowing screw from doorstop'. He was again moved to the health centre and it was at this time he set fire to his tracksuit bottoms.

The following day Dr Das considered that his behaviour was all an act to be placed in the health care centre along with his friend Travis; however, he was discovered with a ligature around his neck which was tied to the end of his bed and he was noted to be banging his head against the wall and biting his arm.

December 1997, his personal officer said: 'A very strange young man…although he has caused no problems on the unit I feel he may suffer from some sort of psychological illness.'

Later that month he was noted to be 'talking gibberish'.

Two weeks later he was seen by a medical officer who said his state of health was good and his state of mind was 'normal'. **[V1]**

TRAVIS enters.

TRAVIS: At HMP Hindley when we shared a cell together we set the cell on fire, both of us did it, we liked the idea of putting people's lives at risk, even our own, we thought

it was funny. I got moved, but eventually we ended up together again. **[V5]**

GUNN: In June 1998 Mr Travis murdered Prisoner A in circumstances which Robert Stewart was to some degree involved.

TRAVIS goes back to the cell with STEWART. They sit and talk together.

STEWART: It's Averill's birthday coming up.

TRAVIS: When?

STEWART: Next week.

TRAVIS: Fucking pig. Let's slice 'im up.

STEWART: Cut his throat.

TRAVIS: I'll stab 'im, you cut his throat.

STEWART: Need a tool.

TRAVIS: Got cookery class next week.

STEWART: Get some blades from the cupboard there.

TRAVIS: Nice one. I fucking hate 'im. He deserves it.

STEWART: Thinks he owns the place.

TRAVIS: Thinks he's a gangsta.

STEWART: Fucking prick, that's what he is.

TRAVIS: Let's give 'im a special birthday present.

STEWART and TRAVIS shake on it.

TRAVIS steps forward again. A POLICE OFFICER leads him to a chair and sticks a tape on to record his statement.

[*] We cooked curry, me and Robert and that…mmmm… me and Robert Stewart…yeah…have cooked a curry… yeah and an apple, no, a jam tart, pie or something like that. I don't know what it was…yeah… We've ate our

curry and that…yeah…the teacher's said, 'Right wash your pots and that'…mmm…so we just put all our pots in the, in the sink…mmm…and then we've ate our jam tart thing… mmm…and then he's started going on saying: 'I want some of this, I want some of that'…yeah…try bullying me for a pie…'cos he's ate his and we took our time with ours, trying to bully us for that…yeah…and then teacher's got some chocolate cakes out, what the teacher's made – yeah – and like 'cos it was Averill's birthday, Averill's saying, 'I'm having your twos. You better say that you don't want none' – yeah – and all this. And then, but I said, 'No you're not having mine', and they're saying, 'Right, you're gonna get battered when you go to the gym. You're going to get leathered', mmm…and it's going on and on. Robert's washing the pots. There's a big carving knife on the side. Averill's coming towards me and then he's just said, 'You're getting knocked out', and stood there staring at me. And then Robert's just passed me a knife and I've just flipped. I didn't mean to kill him or anything like that. Just you know, it was a out of the blue thing, I didn't think what I was doing. Just lost it. I've just freaked out. I've just shut me eyes when I was doing it. **[V1a]**

GUNN: [*] The nature of the involvement is not very clear, but there is some evidence that Robert Stewart knew in advance that Maurice Travis intended to stab A and possibly that Robert Stewart had planned the incident jointly with Travis and/or passed him the knife. There is no record that I am aware of, of a psychological investigation being made on Robert Stewart to determine his mental health, his reasons for the involvement, or an assessment of his future dangerousness. **[V1]**

TRAVIS: [*] After I stabbed Averill I expected Robert to cut his throat as well, but he didn't. That made me angry. We both got arrested. I admitted it. Robert just denied it. He made out he wanted no part in it, but he did and I took the rap for it all. I knew it wouldn't be too long before he killed someone. Eventually he ended up in Feltham and

informed me he was in a pad with a Paki. I just told him to do him and he did it… I know Robert has killed his pad mate – somebody whose name begins with 'Z' and I saw it in the papers. There was no discussion as to how he should kill him – but I know he 'battered' him. [V5]

The POLICE OFFICER switches off the tape and leads TRAVIS away. As TRAVIS goes, STEWART stands in his cell. He looks devastated that TRAVIS has gone.

GUNN: [*] October 1998, after he had lost contact with Travis who was by then on a murder charge, it was noted that RS 'cannot be trusted for even a minute'.

January 1999, he was reported to have swallowed part of a small battery which he said he 'did' for a laugh.

March 1999, an officer noted: 'I do feel as has been said earlier, that this lad is a disaster waiting to happen, he cannot be trusted and I feel as if we are just waiting for our next problem with him.'

16th November 1999, HMYOI Altcourse. C Kinealy writes: 'I spent quite some time today talking to this boy…in my opinion he has a longstanding deep-seated personality disorder. He shows a glaring lack of remorse, feeling, insight, foresight or any other emotion. In my opinion he has an untreatable mental condition and I recommend no further action.'

The CRE report concluded that Robert Stewart had been seen 29 times by medical or health care staff whilst in prison since 1995 but there was no record that he had ever been seen by a psychiatrist. It is easy with the wisdom of hindsight to say that Mr Stewart needed psychiatric attention at several points in his prison career. I think however I must be stronger in my conclusion and say that there were many pointers to considerable psychiatric disturbance in Robert Stewart.

Racism which may play a role in this case is not generally considered to be a psychiatric matter. It's just possible however that in Mr Stewart's case the racism stemmed from underlying paranoid ideas which may be part of a personality disorder of a mental illness.

If Mr Stewart had been recognised as seriously mentally disordered and had been provided with an appropriate and detailed assessment either within the prison itself or preferably in an NHS hospital, it is unlikely that he would have been sharing a cell with Mr Mubarek. **[V1]**

PROFESSOR GUNN snaps his book closed and exits.

IMTIAZ enters carrying files.

IMTIAZ: We started our campaign to get a Public Inquiry; we organised pickets outside the Home Office and we sent out thousands of leaflets publicising our campaign. We got a lot of support from all sorts of people. In April 2001, we wrote to the Home Secretary.

[*] 'Dear Home Secretary,
I'm writing to express my concern at the tragic and racist murder of Zahid Mubarek in Feltham prison in March 2000. All the evidence and internal reports regarding the incident show that murder could have been avoided.' **[V7]**

This was the reply I got:

[*] 'Dear Sirs,
In view of all that has been done to investigate the circumstances of Zahid Mubarek's death and to learn the lessons from it, I do not believe that a separate inquiry would add anything of substance or that it would be in the public interest to hold one.
Yours faithfully,
David Blunkett' **[V6c]**

STEWART is left in his cell. He is scrawling a letter.

A PRISON OFFICER enters and takes STEWART out.

PRISON OFFICER: You're going for a little trip. Go on, get your stuff.

STEWART picks up a bag.

Down to 'the Smoke' for Court. About that nasty little letter you wrote. Go on, take your stuff.

STEWART: Where they taking me?

PRISON OFFICER: Feltham.

SCENE 4

COLIN MOSES steps forward.

COLIN MOSES: [*] *(Geordie accent.)* Colin Moses, Chair of the Prison Officers' Association. I represent 35,000 members of staff.

I've said this on more than one occasion and it's been disputed by some – but I believe that the effect of the tragic death of this young man – Zahid Mubarek – will be the equivalent of Stephen Lawrence's tragic death in the Metropolitan Police Service. (There are differences yes, we know who the culprit was.) I've been in the Prison Service for twenty years – feel very old saying that – I've worked in prisons where I've been the only black member of staff and I've also served in Feltham in 1986. There's a lot of people in the Prison Service who feel very, very insulted by the term 'institutional racism'. You show me another trade union with a black man heading it. I was put here by appointment. I was elected, but how many black and Asian prison officers are being recruited? We have to change the culture of the organisation.

Every person that dies – it has a massive, massive impact on staff. As a black man I felt touched by that death. Actually Zahid would be the same age now, as my son. You hope you put your children in a safe environment.

Every death in prison affects us. That's one of the reasons I made a personal apology from the Union to the family.

Feltham's a massive area. What you do is you go up to the fence and you listen and the noise is absolutely horrendous. Because you're locking children, 16/17-year-old young men into a cell and telling them to be quiet!

There are rapists, murderers, muggers, child abusers in there. These are very disturbed young men.

Feltham is not a hospital. This is not a boarding school.

When you put that light out – people don't go to sleep.

Imagine it, it's light outside, it's a warm balmy night. I'm scared of the dark, I also have nightmares, I'm also locked in this room by myself. I've told my cellmate all my stories, I want to tell you my stories, *(He points up as if to a cell above him.)* you're stronger than me, you torture me through the windows.

I want to make a noise, I'm bored with the television so I just shout and scream, play my music loud, sing along, I masturbate, I do all these crazy things, there's nearly one thousand young men. I may be up all night talking. I may be unable to sleep, someone's shouting at me to wake up.

If you look at the mirror of society – you'll see that we send more young black men to prison than we do to university. We also send more Asian men to prison than ever before – the fastest growing group in prison, religious group that is, are from the Islamic faith. Same with those of mixed heritage and or foreign nationals, and all of this goes unreported.

Conversely we have prisons which have virtually no black or Asian staff.

We work a prison with 127 public sector prisons (private prisons lock up people for profit) and to do that there must be public investment. When you have the largest

or one of the largest YOIs establishment in Western Europe – Feltham – as badly resourced as it is, with lack of investment and lack of staff, what do you expect will happen? There is some excellent unreported work that goes on in some prisons. The vast majority of prison staff are professional, hard-working individuals. There's a lot more to being a prison officer than opening and closing doors.

Seventeen per cent of prisoners are black. In some prisons, it's up to 40/50/60 per cent. Feltham used to run at 55-60 per cent. Pentonville, Brixton, Wandsworth, Wormwood Scrubbs, Belmarsh, Holloway, all with massive ethnic minority populations. Some in excess of 50 per cent. As I said before, in this country, if you're black, you're more likely to go to prison than you are university.

Unfortunately, there are thousands more Stewarts in prison, thousands of mentally-ill young men. There are more than before because we lock more people up.

Don't talk to me about institutional racism of the Prison Service if you aren't going to address the institutional racism of Magistrates' Courts. What sort of sentencing policy have we got when people are being put away for stealing razor blades? In this country there are 75,000 people in prison. That goes up to 83,000 if you include people with tagging. Half a million people pass through the court system. This is a sausage factory industry. There are barristers out there making a lot of money out the system. It's a business. Every night in this country we lock up a small town. **[V2b]**

SCENE 5

IMTIAZ is surrounded by papers, leaflets and files which he is looking at. SAJIDA is there.

IMTIAZ: Can't believe what those prisons are like.

SAJIDA is quiet.

The way they're run!

AMIN enters.

IMTIAZ: We can't let it end like this. They haven't given us straight answers.

Beat.

There's a lot they're not telling us about. Why was Zahid put in a cell with that animal?

AMIN and SAJIDA are silent.

I know they say they're doing enough, this Butt Report and now the CRE Inquiry, but it's not enough. The CRE don't even want us to participate. It's all behind closed doors... If the Prison staff knew this...Stewart...was a racist, why they put him in a cell with Zahid?

Beat.

Suresh says we should carry on. Imran Khan has agreed to represent us. Amin, we gotta fight for justice.

AMIN: Home Secretary won't even meet us.

IMTIAZ: We can do this...

AMIN: How? David Blunkett won't reply to our letters, he won't see us...it's like he doesn't recognise what happened here.

IMTIAZ: Look, what they're doing isn't right. We can do this despite David Blunkett. We don't need his blessing.

IMTIAZ perseveres.

We met Paul Boateng. He agreed there should be a Public Inquiry. People are taking this seriously. We've got the Monitoring Group behind us, we've got a campaign going, these leaflets have gone out to thousands of people, we've

had press conferences, MPs have come out in support of us…

SAJIDA: How will it help us? Will it bring Zahid back?

IMTIAZ: No…but…we could stop it from happening to someone else's son. We got nothing to be ashamed about. Zahid deserved another chance.

SAJIDA: On his own, in that cell…no one there to help him… He must have suffered so badly. Locked up with that mad man…tortured…he was hiding things from me because he didn't want to burden me. Always trying to protect me, wasn't he? Maybe if he hadn't been so secretive, so protective…if he'd told us what this…this…man in his cell was like, we could have done something?

IMTIAZ: If we do this, we have to do it as a family.

SAJIDA: We are ordinary people.

IMTIAZ: I don't know if it'll work but we gotta try. It's not enough that Stewart was put away for life. There were more people involved in Zahid's death than just him. The prison staff knew that he was a racist. It came out in the trial! He'd written over two hundred racist letters while he was in prison! Swastika signs all over them.

AMIN makes a decision.

AMIN: We've lost a life. The least they can do is give us an inquiry after what's happened to us. What would happen if it was one of them? How would they feel? And what would they want out of it?

Beat.

Imtiaz. You be our spokesman.

Beat.

You take it on, Imtiaz. It's too much for me and Zahid's mum. We'll be right behind you every step of the way –

but you gotta do it. Liaise between us and the lawyers and stuff.

IMTIAZ: Right.

AMIN: After all, you've always been the one with the gob on you.

IMTIAZ turns to the audience.

IMTIAZ: In September 2001 we went to the High Court to try and force Blunkett to hold an Independent Public Inquiry... Justice Hooper ruled in our favour and said:

[*] 'An effective and thorough investigation can, in my judgement, only be met by holding a public and independent investigation with the family legally represented, provided with the relevant material and be able to cross-examine the principal witnesses.' **[V8]**

SURESH enters.

SURESH: [*] But in March 2002, the Court of Appeal upheld the Home Secretary's appeal. The Judges said there was no need to hold an inquiry because it had been proven that the prison service had been at fault.

IMTIAZ: It seemed like Blunkett had won. It was a real body blow – like everything we'd fought for was in vain. **[V2a]**

SCENE 6

We are now in Feltham Prison. STEWART is showed into a cell.

PRISON OFFICERS – MARTINDALE and DEBBIE HOGG – approach STEWART.

MARTINDALE: Is this your first time in prison?

STEWART: No.

MARTINDALE: Are you expecting contact with your family and friends?

STEWART: Yes.

MARTINDALE: Do you use drugs or alcohol?

STEWART: No.

MARTINDALE: Do you feel like hurting yourself at the moment?

STEWART: No.

MARTINDALE: Are you feeling suicidal?

STEWART: No.

MARTINDALE: Haven't got a file on you. Better start a new one. What you in Court for?

STEWART: Sending abusive letters.

IMTIAZ steps forward.

IMTIAZ: Stewart came down to Feltham a few times because of Court hearings in London. This was to do with those harassing letters he'd sent to a woman in London. A new arrival in a prison is supposed to have four sets of records: a PER form which is a Prisoner Escort Report form giving key details about the prisoner; a flimsy, which reveals the latest state of play with the individual at the previous prison; a F2050 general file which gives full details of the prisoner's prison history; and an Inmate Medical Record (IMR) which should spell out the possible psychological history. When he initially arrived from HM Hindley Prison he came without any records. So, no one knew anything about Stewart, apparently. Just another young prisoner.

STEWART starts writing letters.

MARTINDALE: [*] On initial interview with the lad on induction, it was just one of those gut feelings where something doesn't feel right...all he did was wander around. He had no friends. That's why we watched him all the time. We were uncomfortable with his presence. On the same day Senior Officer Robert Benford contacted

me and asked me to come over to the security office and he showed me Stewart's security file. His was the largest security file I have ever seen on a prisoner since I have been in the service. I wrote on the flimsy which had been opened that day, in large red capital letters: 'STAFF ARE ADVISED TO SEE THE SECURITY FILE ON THIS INMATE (HELD IN SECURITY). VERY DANGEROUS INDIVIDUAL. <u>BE CAREFUL</u>.' It was down to each individual member of staff to go and find out what the security file contained... I made one entry when I met Stewart. What happens after that has got nothing to do with me. All I was responsible for was when Stewart was in Lapwing with me and nothing else. **[V5]**

STEWART holds out his letter for DEBBIE HOGG. She takes it and as she walks away, she reads it.

DEBBIE HOGG: Erm...dodgy letter from the new boy in cell 15.

MARTINDALE: Dodgy?

DEBBIE HOGG: Goes on about how many black inmates there are in Feltham in comparison to Hindley.

MARTINDALE: And?

DEBBIE HOGG: It's a bit racist. Goes on about 'niggers' and 'pakis'.

MARTINDALE yawns and stretches.

DEBBIE HOGG: What should I do?

MARTINDALE: Give it back to him. Tell him to rewrite it in an acceptable form. Let's not be heavy-handed.

DEBBIE HOGG takes the letter, walks back to the cell and hands it back to STEWART.

DEBBIE HOGG: Stewart – if I were you, I'd change the terminology. It may be racist, it may not be racist, but I don't like what's in the letter so I'm returning it to you.

STEWART: *(Polite.)* Thank you Miss.

MARTINDALE: I remember saying to Officer Meek what a nasty bit of work Stewart was. I have seen an entry dated 7.3.2000 to say Stewart was received on Swallow.

MARTINDALE exits.

STEWART: [*] Well before they put me in a cell with him, they had put this note in my file saying that 'A letter was sent out by this inmate with racially something material', so they shouldn't have put me there in the first place. If they had done the job properly and put me on a remand wing, then it wouldn't have happened. If they'd read the letters when they were supposed to, they should have thought, 'Get the guy out', and the previous files with all these fights and assaults and that in the past. Somebody should have thought I was a time bomb ready to explode. [V5]

SCENE 7

IMTIAZ and SURESH enter.

IMTIAZ: Even though Blunkett had won, we fought on, we lodged an appeal. In October 2003, nearly a year and a half after the ruling against us we took our case to the Law Lords.

SURESH: The Home Office's approach to the Inquiry and to the Mubarek family has been absolutely heartless. If you compare their reaction to the Lawrence family – it's totally different. I think they thought they could get away with this because prisoners are not treated in the same way. The reason why I'm so angry with Blunkett is because I think he prolonged the family's grief.

IMTIAZ: Eventually we won our appeal in the Law Lords. Law Lord Justice Bingham said:

SURESH: *(Reads.)* [*] 'In the light of the House of Lords' judgment in the case of Regina *v* the Secretary of State for the Home Department *ex parte* Amin, to investigate and report to the Home Secretary on the death of Zahid

Mubarek, and the events leading up to the attack on him, and make recommendation about the prevention of such attacks in the future, taking into account the investigations that have already taken place – in particular those by the Prison Service and the Commission for Racial Equality…' **[V9]**

IMTIAZ: [*] It was a remarkable and unanimous decision, asking the Home Secretary to set up an independent Public Inquiry into the death of Zahid Mubarek.

It was the first time ever in judicial history that a family had been able to get such a decision out of the Law Lords.

SURESH: The thing is, what the Stephen Lawrence Inquiry showed us was that you can begin to eradicate racism if you bring it out into the open and the people responsible are held publicly accountable.

IMTIAZ: On the 29th April 2004, over four years after Zahid was murdered, the Home Secretary announced the Public Inquiry into my nephew's death – headed by Justice Keith. Now finally – maybe, we thought, we'd get to the bottom of things. **[V2a]**

JUSTICE KEITH: *(Off.)* [*] Good morning, ladies and gentlemen and welcome to the first day of the full hearings of the Public Inquiry into the death of Zahid Mubarek. The Inquiry's preliminary hearing took place in May. It opened with us observing a minute's silence in memory of Zahid and I know that a remembrance ceremony took place for him this morning.

The initial focus of this Inquiry is on the circumstances which led up to the attack on Zahid, and that will in particular involve an investigation into how he came to share a cell for a number of weeks with someone like Robert Stewart.

The Inquiry will therefore have to address the particular decisions which contributed to that critical cell allocation and any systematic failings associated with them. The Mubarek family believe that race played a part in

those decisions. If any evidence emerges which suggests that that could have been the case, or that race could have played a part in any systematic failings, I regard my terms of reference as requiring me to investigate that as well. To that extent, therefore, my terms of reference make it necessary for the Inquiry to focus on issues of race, over and above the racially motivated nature of the attack on Zahid. My distinguished advisors and I are only too aware of how important this Inquiry is: we know how much it means to Zahid's family who fought so long to get it. We will do what we can to get at the truth so that Zahid's family will at least have the satisfaction of knowing that such lessons as can be learnt from his tragic death may make our prisons a safer place in which to be. [V1]

SCENE 8

We are now with ZAHID. He is in the cell, lying on his bed.

We hear the sounds of Feltham. JAMIE calls ZAHID from his cell. We don't see JAMIE but hear his conversation.

MORSE: *(Off.)* ABW Mubarek.

ZAHID: What's that mean guv?

MORSE: *(Off.)* Arsehole before wicket.

ZAHID: Thank you.

A woman – LUCY BOGUE – steps forward.

LUCY: [*] Lucy Bogue. Former Chairwoman of the Independent Monitoring Board Feltham – IMB.

My perception of Feltham during my time on the IMB was an establishment in turmoil. Yearly budget cuts, high population, shortage of staff and constant Senior Management turnover created an establishment that was difficult to move forward. [V1]

MORSE: *(Off.)* You're taking longer than the test match, Mubarek.

Open cell 38.

LUCY: [*] A key issue during the material time was that Feltham was identified as being a suitable establishment to create a Detention and Training Centre for young men under the age of 18. This meant that a large amount of 'ring-fenced funding' was poured into one side of Feltham, known as Feltham A, which left Feltham B as the poor relation. The knock-on effect of this was that staff left Feltham B to work on Feltham A. During 2000 men on Feltham B were locked up for long periods in disgusting conditions. Those over-18s on Feltham B were left with few if any activities. [V1]

JAMIE: *(Off.)* Oy Zahid!

ZAHID is quiet.

Zahid!

ZAHID: Yeah, what?

JAMIE: I talked to the screw, about us sharing and that.

ZAHID: What'd he say?

JAMIE: Said he'd see how I behaved first.

ZAHID: Gotta stop flipping out man.

LUCY: [*] Each cell contained one lavatory bowl with no privacy screen, 12 inches from the foot of the bottom bed. With only one metal seat, welded to the wall and one metal table welded to the wall, the second person would be forced to eat all meals seated on the bottom bunk, in close proximity to the lavatory bowl. [V1]

JAMIE: *(Off.)* This place is doing my head in. So bored.

ZAHID: Yeah. Nuthin' to do.

JAMIE: Who's got the box tonight?

ZAHID: Dunno.

JAMIE: When's it your turn?

ZAHID: Next Thursday I think.

MORSE: *(Off.)* Open 35.

A Prison Officer – MORSE – steps forward.

MORSE: [*] Ian Morse. I am employed as a Prison Officer. I knew Robert Stewart as a prisoner based on Swallow Unit. I don't recall reading any documents about Robert Stewart during his time on Swallow Unit. Stewart was a quiet prisoner. Zahid was a bubbly character and never caused any problems. **[V1]**

We hear the howl of an inmate, crying.

A plate of food is pushed through into ZAHID's cell. He picks it up reluctantly.

ZAHID: Oh man. That Caps – always howling.

JAMIE: *(Off.)* He's lost it big time.

ZAHID: Same thing?

JAMIE: Sent a VO for his mum, got all dressed up. She never turned up.

ZAHID: Poor bastard.

JAMIE: Least you get visits. Keep you from going mad – visits.

ZAHID: Caps must know the score by now?

JAMIE: You'd have thought. He's a twat. What's he expect? His mum's a whore. *(Shouts.)* Caps! Shut up! Your mum's a fucking whore!

LUCY: [*] The number of prisoner movements in 1996 was in excess of 38,000. The result of this high turnover was that sentence planning became increasingly difficult as there

was a rapid allocation of 18-21 year olds to other prisons. **[V1]**

JAMIE: 'Least you've got a short sentence. How long you been here?

ZAHID: Twenty-three days.

JAMIE: I'm stuck here for years.

ZAHID: Yeah man. Stinks.

LUCY: [*] With the Feltham B prisoner population in constant flux, it became increasingly hard for all members of staff to forge relationships with boys or properly manage their time spent in the establishment. This, added to the existing problems of overcrowding, led to the demise of any fulfilling or substantial regime for boys on Feltham B. **[V1]**

MORSE: [*] I made an entry in Robert Stewart's flimsy when he arrived on Swallow Unit from Reception. I was also responsible for allocating him to cell 38. February 8th 2000. **[V1]**

JAMIE: *(Off.)* 'Least you can read books and stuff.

ZAHID: Like I said. We get to share a cell and I'll teach you.

JAMIE: Maybe if I tell that to the screws they'll move us in together.

ZAHID: Maybe.

LUCY: [*] A common complaint throughout Feltham B was the lack of evening association. Association is the time that prisoners have out of cells in order to socialise with other prisoners. The boys might play pool. **[V1]**

MORSE: *(Hands ZAHID a plate of food.)* Open cell 38.

LUCY: [*] In the rota book, on 16.2.2000 (five weeks before Zahid's death), a Board member noted that whilst boys in Swallow Unit should have two hours of association, there was no sign of any boy being unlocked after 2.45pm. It

must be understood that the paucity of the regime would have meant that boys would spend up to 22 hours locked in a cell. Feltham at this time had no in-cell electricity and so there was little for the prisoners to do. [V1]

ZAHID: Starvin'.

JAMIE: *(Off.)* Yeah, me too. I could do with some Kentucky Fried Chicken.

ZAHID: Don't…

JAMIE: Finger lickin' good.

ZAHID: Me, I want my mum's chicken biryani.

JAMIE: Sounds good to me. Food here smells like shit.

ZAHID looks at his plate of food and sniffs it. He tries to eat.

ZAHID: Probably is shit.

JAMIE: Euch. Don't say that!

ZAHID laughs.

MORSE: [*] I was on the desk at 7.30pm. I can't recall what cells were vacant in Swallow Unit at the time but the unit was usually very full so often there was very little choice as to where the prisoners would be allocated. I didn't have any concerns about Robert Stewart. [V1]

LUCY: [*] It was the opinion of myself and the Board that the impact of 22 hours locked in a very confined space must have had an adverse effect on the behaviour of any adolescent, let alone some of the most damaged and disturbed adolescents in the country. The lack of fulfilling association time was both degrading and disgusting. [V1]

JAMIE: *(Off.)* Oy. Zahid.

ZAHID: Yeah.

JAMIE: What d'you miss most from outside?

ZAHID thinks.

You hear me?

ZAHID: Yeah. Miss playing cricket with me brothers in Vestry Park. Yeah man. Miss that the most. You?

JAMIE: Everything.

ZAHID slides his tray of food out along the floor of the cell.

MORSE: [*] On that night I would have had no information about Stewart other than his name and prison number, remand or convicted and how long serving, I would have checked the available spaces on the wing... I had a cell card and one space and one prisoner. [V1]

STEWART enters. MORSE leads him towards the cell.

Cell 38, opening doors.

ZAHID sits up on his bed.

Got a new cellmate Mubarek.

STEWART stands before ZAHID. They look at each other.

STEWART: *(To MORSE.)* When's my money coming from Hindley, boss?

MORSE: Don't know. I'll check it out for you.

STEWART sits on the bed.

MORSE glances at them both and then exits.

The scene ends with the two young men wordlessly sat on their beds looking at each other.

INTERVAL.

Act Two

SCENE 1

We hear a tape recording of a very emotional man on the phone speaking.

VOICE: [*] I'm no bleeding heart on this but that kid was murdered for other people's perverted pleasure. The game was called 'Coliseum'. Mubarek was killed because people thought it was funny to see what would happen when they put a young Asian lad in with someone who wanted to kill Asians. Now Mubarek wasn't the only victim in there. He was the victim that died.

DUNCAN KEYS steps forward.

The usual wall of silence has gone up through the Prison Service as you would expect, but they can no longer sit there and hear the question about how Mubarek ended up in a cell with a known racist. That's how he ended up. Because of a game called 'Coliseum' and staff in that wing.

If the right questions had been asked on the Butt Inquiry instead of looking at processes and procedures and all that rubbish and actually found that it was human beings that put those two people together rather than bloody processes and procedures – then there would be a murder inquiry into the staff there. Because it's something that went dramatically wrong. Dramatically wrong. [V5]

Tape is switched off.

KEYS: [*] Duncan Keys. I am employed as an Assistant Secretary for the Prison Officers' Association.

I can confirm that it is my voice on this recording and I made this call, having tried and failed to speak to someone at the CRE by telephone the previous day. I made this

telephone call as I felt that the information was important and could be relevant to the Public Inquiry. I also felt that it could be relevant to the death of Mr Mubarek. The first time I ever heard of a practice whereby two prisoners were put in a cell together in the expectation that they might fight was when I spoke to Tom Robson after he had visited Feltham Prison. Tom is a member of the National Executive Committee and a good friend of mine. He told me that they were in the Prison Officers' Association office when Mr Herring had started to tell him about a game played by prison officers in Feltham known as 'Gladiator' or 'Coliseum'. **[V1]**

HERRING: [*] Nigel Herring – Branch Chairman of the Prison Officers' Association. I have never instigated or taken part in a practice known as 'Gladiator' or 'Coliseum'. The only committee member from Feltham who had previously heard rumours about 'Gladiator' was Ian Morse. I remember him saying that he had heard these rumours in connection with an investigation. **[V1]**

KEYS: [*] The prisoners could be one black, one white, one big and one small, one bully paired with another bully. Whatever the combination, the intention was to see whether or not the two fell out and came to blows. Tom told me that Mr Herring had told him that the officers were betting on the outcome of such pairings.

Having come to the conclusion that the Union was not going to do anything to draw these allegations to the attention of the authorities, I decided that I had to take some steps to make sure that the information came to someone's attention. I was however extremely nervous about making a direct, open approach to the CRE because I had previously raised the matter with my line manager, Brian Caton, and he had told me that I should do nothing. As a result, I decided to make an anonymous call to the CRE. **[V1]**

HERRING: [*] I would also like to emphasise that I have not witnessed or taken part in banter malicious or otherwise about Mr Mubarek's death. [V1]

KEYS: [*] I accept with hindsight that I exaggerated aspects of what I said but did so because I wanted to make the allegations seem strong and plausible, because I thought that the issue should be investigated. In my interview with the Police I was asked by DI Booth about my statement that the practice known as 'Gladiator' was linked to Zahid Mubarek's death. I explained in that interview that I had put two and two together and came up with five. The fact that I did so and the fact that I linked this practice with the death of Zahid Mubarek, when I now appreciate that there was no direct evidence that his being placed in the cell was anything to do with this practice, is a matter of considerable regret to me. I offer my sincere apologies to the Mubarek family for the hurt I have caused by my actions. [V1]

HERRING: [*] Any 'Gladiator' practice would have to involve the complicity of many officers. The great majority of officers have complete commitment to the welfare of prisoners and would not shrink from reporting any misconduct of this kind within a short time. No such practice could survive or be kept secret. [V1]

KEYS: [*] I, initially thought that the possibility that such a practice was ongoing was unlikely, although I was aware that there had been previous instances of inappropriate behaviour by Prison Officers at Feltham and accordingly, I did not dismiss the possibility that this might have gone on. [V1]

HERRING: [*] If you haven't got the staff to even give these guys breakfast, or take them to work, what do you get? 'You're winding us up, you're trying to wind me up.' And we're dealing with very angry people, that go, like that, they will stab you just like that, and that's why they're there. [V3]

IMTIAZ and SURESH enter.

IMTIAZ: [*] Unless it's eliminated there's always gonna be an element of doubt. If you're looking at the facts of how Stewart manages to go through two prisons, Hindley first and then Feltham, undetected, the amount of opportunities that they had, the prison officers, to stop this guy – they could see that he was dangerous and hence they should have allocated cells accordingly – it doesn't make sense. It is just so far out there that you've got to think that somewhere along the line somebody had something to do with helping him along… I don't know… I really don't know…the way these two just come together in one cell – it just doesn't really make sense. I mean, you've just gotta take a look at his convictions. [V2a]

SURESH: [*] If the 'Gladiator' thing is true, then apart from Stewart murdering, then someone else is responsible for manslaughter or murder – so it became a Police investigation. The Police said they were going to close the investigation on this because it was impossible to determine. But Duncan Keys comes across as an extremely convincing witness. Nigel Herring does not. You can talk to prisoners and they'll tell you about this thing called 'wind ups'. Prison officers say this doesn't exist. [V2a]

NIGEL HERRING and DUNCAN KEYS look at each other with hatred and then exit.

IMTIAZ: [*] Originally we weren't sure about whether any of the staff at Feltham knew that Stewart had a history. We just thought that those reports hadn't gone through. This was what I was thinking.

SURESH: Yes, me too.

IMTIAZ: But in the Inquiry I saw there were reports that were read and still they never did anything about it. There were people that knew that Stewart was a handful. They did nothing.

That's where the real 'Gladiator Games' has been, between the family on one hand and the Prison Service and the British Government on the other. It's a shame you have to ask the Government to invest in the truth. **[V2a]**

SCENE 2

In the Association room, STEWART is playing table tennis with INMATE 1. STEWART having lost his game starts smashing the bat against the table repeatedly.

STEWART: Fuck's sake.

INMATE 1: Keep your hair on mate. It's just a game!

STEWART continues to smash his bat up. We hear unseen FELTHAM PRISON OFFICER shout.

FELTHAM PO: *(Off.)* Oy! Inmate Stewart. You break that bat and you'll have to pay for it.

JAMIE: *(Off.)* Oy oy oy oy!

STEWART calms down immediately and goes into a corner.

ZAHID and JAMIE enter. JAMIE looks at STEWART.

ZAHID: Jamie, leave it man, calm down.

JAMIE: What's your new padmate like?

ZAHID: Safe.

JAMIE: Yeah?

ZAHID: Acts a bit weird but seems all right.

JAMIE: Looks weird all right. Where's he from?

ZAHID: Manchester – doing time at Hindley. Sounds like he's been inside forever. Don't like the things on his head. Think he's NF.

JAMIE: Said anything nasty?

ZAHID: Doesn't talk much.

JAMIE: Everyone calls him RIP.

ZAHID: Yeah.

JAMIE: I asked about moving cells again.

ZAHID: Any luck?

JAMIE: Said he was 'too busy'.

ZAHID: Go and ask again.

JAMIE: All right.

SKINNER steps forward.

SKINNER: [*] Stephen Skinner. At the time of the attack on Mr Mubarek my position was that of a prison officer based on Swallow Unit. I knew Zahid Mubarek from working on Swallow Unit. He used to come over and chat to the officers working on the unit when it was association time. During these conversations with Zahid he never expressed any concern to me about his safety or indeed about his cellmate. [V1]

STEWART and ZAHID go back to their cell and are locked in.

STEWART: You got a girlfriend?

ZAHID: Nah.

STEWART: I have. She's banged up 'n' all.

ZAHID: Inside?

STEWART: Yeah. Writes to me and stuff. I write back. I love writing – me.

ZAHID: Nice one.

STEWART: Wrote to her last week. Told her I was gonna chop off her head.

ZAHID looks at STEWART as if he's mad. STEWART laughs. ZAHID fiddles with his radio and sticks some music on.

What is that crap you listen to all the time?

ZAHID: It's not crap. It's Biggy.

STEWART: Put something else on.

ZAHID: It's my radio. What kind of music you listen to?

STEWART: Not this shit.

ZAHID: What then?

STEWART: Not this shit.

ZAHID: What rock music?

STEWART: Not this shit.

ZAHID: What pop music?

STEWART: Not this shit.
Not this shit.
Not this shit.
Look at my fucking house.
Look at my fucking car.
Look at my fucking birds.

ZAHID: I like it.

STEWART: Jigaboo, nigger gangsta rap shit.

ZAHID: It's my radio. I'll listen to what I want.

STEWART: I hate it.

ZAHID: Tough.

STEWART: Fuck's sake.

STEWART lies on his bed and covers his ears with his pillow.

JAMIE steps forward.

JAMIE: [*] Jamie Barnes. I am a convicted prisoner and am presently at HMP Wellingborough. Zahid and me were friends and I first asked Prison Officer Skinner some time in February 2000 whether I could move into Zahid's cell. To the best of my recollection I think this conversation took place in the office overlooking Swallow Unit's association area and Zahid was with me when I asked. The only reason I asked was because Zahid and I were friends and I was fed up being in cell 35 on my own. **[V1b]**

STEWART leans forward on his bed and stares weirdly at ZAHID. ZAHID looks unnerved.

ZAHID: What you starin' at?

STEWART: Nuthin'.

STEWART continues to stare.

JAMIE: [*] I don't remember now what Skinner's response was but nothing came of my request so I repeated it to another officer, Morse, a few days later. Again the conversation took place in the Unit office but I don't remember if Zahid was with me this time. **[V1a]**

MORSE steps forward.

MORSE: [*] I have no information about any requests made by Zahid Mubarek to move to another cell. If he wanted to make another request and if he had spoken to an officer then it would have been suggested to him that he should fill in an application form. **[V1]**

STEWART stops staring at ZAHID and lies on his bed.

STEWART: You comin' off drugs?

ZAHID does not reply.

Always lying around, you are. Look like you're comin' off drugs.

ZAHID: Haven't had a shower for days.

STEWART: You fucking stink.

ZAHID: Not my fault. Showers are busted again.

ZAHID gets up and combs his hair. He tries to make himself look presentable and sprays himself with deodorant. He stands by the cell door waiting patiently.

JAMIE: [*] Still nothing came of my request so about two days later I again asked Skinner. This time he said he was busy and no cell moves could happen that day. A day or so later Stewart was moved into Zahid's cell. **[V1a]**

ZAHID leaves the cell and goes to the visitors' room. STEWART stays in the cell and starts to write letters. ZAHID meets his mum and dad, AMIN and SAJIDA. They embrace.

AMIN: How's it going?

ZAHID: Yeah, all right. It's okay.

SAJIDA: You getting enough to eat?

ZAHID: Yeah. Food's great here. No worries Ammi.

SAJIDA: You look thin.

ZAHID: Kind of lose your appetite a bit in here. Not really doing much exercise.

AMIN: Gettin' on all right with the other lads?

ZAHID: Yeah. Some of them are right troublemakers. Make me look like an angel.

AMIN and ZAHID laugh.

STEWART reads out one of his letters.

STEWART: [*] IT'S SHITE IN ERE, PLANET OF THE APES. AV GOT A PADMATE TO COME BACK TO (A PAKI). **[V6b]**

ZAHID: How're me brothers? Okay?

AMIN: Yeah. They're fine. Missing you.

ZAHID: I miss them. Don't bring 'em here again will ya?

AMIN: They want to see you.

ZAHID: It ain't right – them hanging about here. Don't want them to end up like me.

Back in the cell we see STEWART writing a letter. We hear him reading it out.

STEWART: [*] 23RD FEB 2000

CANNOT SEE IT STICKIN' IN ERE.

IF I DON'T GET BAIL ON THE 5TH, I'LL TAKE XTREME MEASURE TO GET SHIPPED OUT, KILL ME FUCKIN' PADMATE IF I HAVE TO; BLEACH ME SHEETS AND PILLOWCASE WHITE AND MAKE A KLU KLUX KLAN OUTFIT AND WALK OUT ME PAD WIV A FLAMING CRUCIFIX AND CHANGE THE CROSS TO A PLUS AND THEN A SWASTIKA WIV A BIRO. (HA) NAH, DON'T THINK I'LL BE THAT HARD, THOSE SCREWS DON'T KNOW ME LIKE THESE AT HINDLEY. I SENT YOU A VO LAST WEEK WITH THE VISITORS NAMES, ADOLF HITLER, CHARLES MANSON, HAROLD SHIPMAN...SIGNED STEPHAN LAWRENCE. [V6b]

We see STEWART ripping a leg off the table. He breaks the leg in two and fashions the smaller splint into a dagger. He replaces the table leg to prop up the table.

ZAHID: Grandma and Grandpa?

AMIN: Missing you too.

ZAHID: Spoke to them on the phone last week.

SAJIDA: They are both praying for you to get out early.

ZAHID: Good. Feeling a bit homesick actually. Miss my cricket and you know – the family and that.

AMIN: You haven't got long in here. Take the punishment, learn from it and then you can move on.

ZAHID: Yeah, yeah…

AMIN: You sure everything's okay?

ZAHID: Got a new cellmate. He's a bit weird. Just sits there and stares at me, sometimes for ages. Doesn't say nuthin'. He's got this tattoo on his forehead. Says RIP you know?

AMIN: 'Rest In Peace'?

ZAHID: Yeah. I've asked to change cells.

AMIN: Just keep your head down son and do your time.

JAMIE: [*] Zahid never complained to me about getting racial abuse from Stewart nor did I ever get the impression that he felt threatened by him. Stewart was a quiet guy who tended to keep to himself and he was never abusive or violent to me or anyone else as far as I know. **[V1a]**

ZAHID stands again, hugs his mum and dad and then goes back to his cell. As he enters he sees that STEWART looks cagey.

ZAHID sits on his bed. They sit in silence. ZAHID writes a letter.

[*] However I got the impression he was racist, mainly from his appearance and demeanour and the way he acted. He rarely mixed with other people and would wait to shower until everyone had finished. When he did speak to people it was mainly to members of the white gangs. He would mainly refer to black people in a fairly muted way as 'them', but it was clear to me that he didn't like them. I don't think he realised that I'm half-Indian by birth and, if he had, that he would have made those comments to me. **[V1a]**

We are back in the association room. STEWART and others are playing table football, etc. JAMIE is there chatting etc.

ZAHID comes down the stairs looking a bit pissed off. He approaches STEWART.

ZAHID: The Guvnor found your stuff in the toilet.

STEWART smiles.

STEWART: Don't care.

ZAHID: They did a cell search. I got the rap for it.

STEWART: So?

ZAHID: I got the rap for it!

STEWART: You gonna grass on me? You wanna take this to the showers?

ZAHID: Leave it out. What's happened here?

STEWART: Table's broken, just propped it up. They never found the other one.

JAMIE: What you chattin' about?

STEWART pats his stomach.

What?

STEWART lifts his tracksuit and shows the boys.

You got a tool? Where d'you find that?

STEWART: Made it myself. Protection.

JAMIE: Oy, Zahid, can I have me radio back?

ZAHID: What radio?

JAMIE: The one you borrowed off me.

ZAHID: Gave it back mate.

JAMIE: No you didn't.

ZAHID: Did. Last week. Gave it back.

STEWART joins in the game.

STEWART: He did.

JAMIE: Stop fucking me around…

ZAHID: You're losin' your memory man. Gave it back, didn't I?

STEWART: Hold up. You sold a radio last week didn't you? Was that Barnesy's?

ZAHID: Come to think of it…

JAMIE: Stop winding me up.

JAMIE marches off to ZAHID and STEWART's cell. The other two follow him calling out as they go.

ZAHID: Oy – you can't just walk into our pad.

STEWART: Yeah…need our permission.

JAMIE goes into the cell and starts patting down ZAHID's bed. ZAHID and STEWART continue winding JAMIE up.

ZAHID: Got a fiver for the radio. Could go halves on it if you like.

JAMIE: You're gonna give me two pounds fifty for my radio? You're takin' the piss.

STEWART: Be fair – it was a tenner.

STEWART and ZAHID are now passing the radio between them and winding JAMIE up. JAMIE's furious.

JAMIE: Give it back!

ZAHID: Wasn't your radio anyway, you nicked it off someone else didn't you?

JAMIE: Fuck off.

STEWART is enjoying the wind up. Eventually, ZAHID relents. He gives back the radio. JAMIE snatches it back ungraciously. ZAHID is laughing. JAMIE is pissed off. He makes as if he's going to take a piss.

What a laugh – eh? What a fucking mansion it is in here. Think I'll take a piss in here.

STEWART momentarily looks annoyed. His hand goes to his weapon.

ZAHID, still laughing, pushes JAMIE out of the cell.

ZAHID: Come on man, we were just winding you up.

JAMIE exits, annoyed. ZAHID goes back to his cell.

It is the end of association.

A woman – JUDY – steps forward.

ZAHID and STEWART are in their cell.

JUDY: [*] Judy Clements. Race Equality Adviser to HM Prison Service.

During my regular prison visits, I spoke to Black and Minority Ethnic (BME) prisoners and received countless reports of alleged ill-treatment, believed to be on the grounds of race, as well as accounts of blatant racism, usually in the form of name calling. [V1]

ZAHID is lying on his bed whilst STEWART is staring at his belongings.

STEWART: You been nicking my stuff?

ZAHID: What stuff?

STEWART: My stuff.

ZAHID: What stuff?

STEWART: You been usin' me shower gel? Me writing paper?

ZAHID: No.

STEWART: Don't fucking lie to me.

ZAHID: What you on about?

STEWART: It's been moved. I can tell.

JUDY: [*] The main concerns raised by BME prisoners can be summarised.

Frequently being 'shipped out' if they complained that they were being subjected to racist behaviour by fellow prisoners or staff.
Being refused access to telephones.
Being placed in segregation units.
Being located in establishments a long way from their homes and family.
The limited availability of ethnic food. [V1]

STEWART stares at his stuff again.

STEWART: It's not where I left it.

ZAHID: It's where you always leave it.

STEWART: I know. It's been moved.

ZAHID: You probably moved it. I got my own things – why would I want to touch your stuff?

STEWART: Can't you understand me accent or somethin'? I said I can tell.

STEWART stares angrily at ZAHID.

ZAHID: Take a chill pill.

STEWART: I know what you lot are like. Fucking robbin' us all the time.

ZAHID: Fuck off.

STEWART continues to stare at ZAHID. ZAHID looks unnerved. He gets up and starts pacing.

JUDY: [*] Most disturbing were allegations of acts of serious violence against BME prisoners and the disparity amongst prison staff in reporting these matters as racist. Prison staff and management at local level were, in most areas, in complete denial that BME prisoners were subjected to any form of racism. Consequently they seldom intervened. [V1]

STEWART: I know you took me stuff. Just admit it.

ZAHID: I didn't touch it.

ZAHID calls out to JAMIE.

JUDY: [*] I found in every prison that I visited that BME prisoners were disproportionately over represented in the prison discipline regime and were adjudicated upon far more that the majority white prison population. **[V1]**

ZAHID: Oy! Jamie.

We see JAMIE in his cell smoking a cigarette.

Jamie!

JAMIE: What?

ZAHID: You got a burn?

JAMIE: Nah mate. Given up.

ZAHID: Don't give me that.

JAMIE: Health kick.

ZAHID is more agitated.

STEWART: Look at you. Always so agitated.

ZAHID: I ain't even talkin' to you. I ain't got your shit.

ZAHID lays down again.

STEWART is now standing in the cell. He calls out to JAMIE.

STEWART: Hey! Barnesy.

JAMIE ignores him.

Barnesy! You got a burn?

JAMIE: Fuck off.

STEWART: Me padmate's been nicking me shower gel and writing paper.

JAMIE: Thought he smelt nice. Hey Zahid!

ZAHID ignores them both.

JAMIE: Cool and refreshin' eh mate?

ZAHID: Shut up Jamie.

JAMIE laughs. STEWART sits back down and stares at ZAHID.

STEWART: We'll see who has the last laugh on this one.

SCENE 3

We are back in visiting hours again. SAJIDA and AMIN enter. ZAHID joins them. They embrace.

SAJIDA: Only two more days to go Zahid.

AMIN: You're nearly there lad.

ZAHID: Who's going to be there?

AMIN: Your cousins, your brothers, your uncles. Nothing too big.

ZAHID: Can't wait dad. Can't wait. Be so nice to get out of here. I'm gonna get a job, sort myself out, you'll see, You'll be proud of me.

SAJIDA: We are always proud of you…this is just…

AMIN: You slipped up Zahid. Things are gonna be different. We'll see you right.

ZAHID: What're you gonna cook mum?

SAJIDA: Your favourite – chicken jaal.

ZAHID: Ohhh…feel like I haven't eaten for months.

SAJIDA: You have lost weight.

ZAHID: I'm sorry dad, mum. I'm sorry about all this stuff I put you through.

AMIN: As long as you've learnt your lesson.

ZAHID: I think they're releasing me on Tuesday.

AMIN: I thought they were supposed to be releasing you two days ago?

ZAHID: Yeah – didn't work out 'cos they hadn't done the paperwork. Still haven't moved me. Cellmate's still acting weird.

AMIN: Yeah well, you'll soon be out of there. Then you won't have to worry about him no more.

ZAHID stands up to go back to his cell. He hugs his parents again.

ZAHID: So you'll be picking me up?

AMIN: I'll be here.

They watch him go. ZAHID turns.

ZAHID: Hey dad! Don't be late! Bring the Cosworth. And dad – don't be late.

ZAHID goes back to his cell.

ZAHID: It's our turn for TV tonight.

STEWART: What's on?

ZAHID: Some Russell Crowe film.

STEWART: Which one?

ZAHID: *Romper Stomper.*

STEWART: Shit! That's a great film!

TV is flicked on. Stage goes dark as we hear (or indeed see) the opening violence of the film.

SCENE 4

We are at the Inquiry. GIFFIN steps forward.

GIFFIN: [*] Counsel for the Zahid Mubarek Inquiry – Giffin.
Closing statements.

Sir, these submissions are made at the end of a long
process of investigation of the events which led to the
murder of Zahid Mubarek and of the context in which
those events took place. That investigation has extended
to the assembling and consideration of more than 15,000
pages of documents, the taking of written statements from
some 110 witnesses of fact, reports from two distinguished
consultant psychiatrists and the hearing of oral evidence
from 60 witnesses spread over some 64 days. That
represents an enormous intake of information.

Much public attention has been paid, understandably so,
to the suggestion that Zahid might have been the victim of
a deliberate practice of officers placing prisoners in shared
cells in the hope or expectation of racial violence or other
conflict between them: the so-called 'Gladiator' allegations.
I do not believe that there is any evidence from which
you could conclude that Stewart was deliberately either
placed or left with Zahid in the hope that that violence or
conflict would occur between them. The true facts are quite
sufficiently disturbing without being reduced to that facile
form. Nonetheless, there remains alive the suggestion that
some such practice did occur at Feltham at some time and
on some unascertained scale. [V1c]

*We see ZAHID and STEWART in their cell. ZAHID is getting ready for
release the following morning. STEWART is watching him.*

[*] Even if we leave aside the history of events before 1999,
there were I think, potentially as many as 15 occasions
when individual prison staff, sometimes now identifiable,
sometimes not, might have influenced the course of events
if they had acted differently in response to the information
they had.

1 We know that on 7th March 2000, a fortnight before
 the attack, a prison officer, Mr Morse, had open
 before him the wing file warning that Stewart was very
 dangerous and recording that he had written a racist
 letter, yet he remained in the cell with Zahid, no action
 taken.

2 We also know that the next day another officer, Mr
 Skinner, had the same file in his hand, marked in red
 on its cover 'See inside', yet Mr Skinner took no action.

3 There is then the important suggestion that a day or
 two preceding Zahid's death, a piece of wood was
 found by a prison officer in cell 38 which could and
 should have led to the identification of the broken table
 and to the realisation that Stewart had been making
 weapons.

4 Both of Stewart's personal officers admit they never
 took any positive steps to find out anything about him
 or Zahid or to make entries on his wing file. If they had
 done so, they would have seen the written warnings
 there.

5 When Stewart came to Feltham for the third time there
 was no vetting of his security file.

6 When Stewart wrote a racist letter on Lapwing Unit
 which was intercepted on January 12th 2000 and shown
 to Senior Officer Martindale, no action was taken.

7 Someone will have checked Stewart's warrants or
 certainly should have done when he entered Feltham
 and seen that he was charged with offences under
 the Harassment Act, yet his correspondence was not
 monitored and so letters which revealed his violent and
 racist thoughts were never seen.

8 No warning about Stewart's violence based on his PER
 (Prisoner Escort Record) was passed onto the wing.

9 The wing file containing Mr Martindale's warning and
 the information about the racist letter was allowed to go
 missing at some point between 12th January 2000 and

7th February 2000 and when Stewart was allocated to a cell without any attempt then or later to pursue the missing wing file or seek information about it.

10 At Hindley there were a number of failures in the autumn of 1999 and at the start of 2000 to record incidents properly on Stewart's security record, so conveying to anyone who looked at it the false impression that his record had been clean since January 1999.

11 At Altcourse, Stewart was or may have been assessed as not being dangerous without the individual who reached that conclusion being made aware of the contents of his security file.

12 At Hindley, it is likely in my submission that staff were informed that on 19 September 1999 Stewart had sent a harassing letter from the prison, but no security report was raised and:

13 No action was taken to monitor his correspondence.

14 At Altcourse, the prison was informed that Stewart was to be questioned by police about alleged offences of racial harassment, but nothing was done to find anything more about the circumstances.

15 At Hindley, letters from Stewart were intercepted in August 1999 and January 2000 which led to security reports but not to any further action. [V1c]

We see a FELTHAM PRISON OFFICER look into the cell on his night rounds to check they are all right. STEWART is writing letters.

It is now night time and ZAHID is tucking himself into bed. STEWART stands and reads out one of his letters. (Some stagecraft to signify this is all going on in STEWART's head.)

STEWART: [*] DID YOU WATCH ROMPER STOMPER? IT'S MAD. I'M IN IT. HA HA, WISH THEM SKINHEADS WAS IN ERE, NIG NOG WOULD SOON SHUT UP I THINK. AM GONNA MAKE ME OWN BEER IN ME PAD, WATCH ME SOME TV

AND TUMP [thump] UP SOME JIGABOOS. GONNA NAIL BOMB BRADFORD, MOSS SIDE – ALL THE NON WHITE AREAS. [V6b]

STEWART sits down to write another letter.

O'CONNOR steps forward.

O'CONNOR: [*] O'Connor. Closing Submissions on behalf of the Mubarek family.

Sir, at the outset may we, on behalf of the Mubarek family, publicly express our appreciation for the sensitivity with which the death of Zahid has now been investigated. The murder of Zahid devastated his family and rightly shocked the nation. It is incomprehensible to the Mubarek family and to the public that he could have been forced to share a cell with Robert Stewart for six weeks. [V1c]

STEWART stands up and reads another letter. ZAHID rolls over in bed.

STEWART: [*] WELL DID YOU WATCH ROMPER STOMPER THE OTHER DAY? LET'S GO GET THE GOOK'S. MAD DAT FILM STARRING <u>ME</u>! [V6b]

ZAHID: *(Calls out.)* I'm tryin' to sleep, switch the light off.

STEWART ignores ZAHID.

STEWART: [*] DID YOU WATCH ROMPER STOMPER THE OTHER DAY. FAT FILM. I WISH DEM BLOKES WERE IN ERE AND DEM WHAT KILLED STEPHEN LAWRENCE. THE NIGGERS WOULD SOON SHUT UP... AM GONNA CONTACT THE FIVE O AN ADMIT TO SOME SHIT, NICE SPELL UP NORTH WEST, WATCH SOME GRANADA TV, HEAR SOME REAL ACCENTS, SEE SOME WHITE PEOPLE. [V6b]

O'CONNOR: [*] It is remarkable how little remorse has appeared from the mouths of witnesses before the Inquiry. A reluctance even to acknowledge collective fault has been shown.

What is the relevance of race discrimination at Feltham to this murder? This provided an institutional context for Stewart's racism to thrive and come to its appalling fulfilment. Ms Clements, in her evidence, said: 'I think there is in my mind no doubt that race and racism had a key part to play', and she has asked in her evidence: 'Could we have been so blind?' The blindness of the threat he posed to ethnic minorities is testament to the blinding power of racist attitudes. **[V1c]**

STEWART paces the cell, writing and reading his letters. He seems to be working himself up into a frenzy.

STEWART: [*] I'M GONNA NAIL BOMB THE ASIAN COMMUNITY OF GREAT NORBURY, ST LUMM RD + THEM AREAS. IT'S ALL ABOUT IMMIGRANTS GETTING SMUGGLED IN HERE. ROMANIANS, PAKIS, NIGGERS, CHINKIES TRYIN' TO TAKE OVER THE COUNTRY AND USING US TO BREED HALF CASTES. **[V6b]**

ZAHID: Switch the light off.

STEWART chucks a pair of his underpants onto the light.

O'CONNOR: [*] Let us engage in a life swap in which Zahid Mubarek and Robert Stewart exchange ethnic origin and religion but nothing else. Zahid is a white Christian and Stewart a black Muslim. The prison officer on duty has been warned that the Muslim Robert Stewart is dangerous to staff. She has several options for cell-sharing. Even on appearance alone, is there any chance she would have allocated that Robert Stewart to share with a white Christian prisoner? The white Zahid Mubarek would never have been subjected to the apparent threat from the black or Muslim Robert Stewart for one night, let alone six weeks. **[V1c]**

STEWART reads one last letter.

STEWART: [*] I LIVE A LIFE OF CRIME, ALCOHOL, VIOLENCE, DRUGS, PRISON, CARS, RACISM + GIRLS. LET ME KNOW YOUR VIEWS ON BLACKS + ASIANS. [V6b]

O'CONNOR: [*] The Prison Service and the Prison Officers' Association seek to downplay the role of racism as a motive for this murder and the role of institutional racism as a contributing factor. We venture to submit that very little of what we have learnt about Feltham in the years 1996 to 2000 can be dismissed as entirely irrelevant to the murder of Zahid.

It is right to say that almost every area of life in Feltham which can be assessed or measured by the Inquiry has been shown to have been tainted with race discrimination. If there had not been institutional racism within the prison service, it is more likely that Zahid Mubarek would be alive today. That is why the family believes this issue to be of such importance in their son's death. [V1c]

We see STEWART sitting on his bed, staring at the sleeping figure of ZAHID. Eventually he takes the table leg from its hiding place and approaches ZAHID. He stands over ZAHID with the table leg in his hand.

[*] Zahid lost his life on the morning of his due return from Feltham to his family. He had faced up to his problems in a very mature way. They were surely in the past for him. The Inquiry has seen his letters to his family where he apologised directly and openly to his father for letting him down. He was concerned to set a good example for his two younger brothers. The positive hard-working and athletic side of his life would probably have been channelled into an army career. [V1c]

ZAHID: Switch the fucking light off.

O'CONNOR: [*] His memory has been frozen at this moment by an act of cruel racist violence. Nothing can bring him back. One of the manifestations of ideological racist hatred

over the last century has been the cynical distortion of language. This has the nihilistic power to undermine the rational part of the human spirit which racists know is their enemy. This was the intended effect of the letters 'RIP' on the forehead of Robert Stewart. The simple sentiment of 'rest in peace' to the dead is turned into a threat of murderous violence addressed at whoever looks at his face. That abomination of language remains the message of those letters to the Mubarek family, at least for the moment. This Inquiry can at least reclaim the humanity of that simple sentiment and enable the family to ensure themselves that Zahid does, in the true sense of the words, rest in peace. **[V1c]**

STEWART brings down the table leg onto ZAHID's head. The lights go out.

ZAHID: *(Shouts.)* Ahhh!

STEWART: *(Shouts.)* Shut up! SHUT UP!

We hear the sound of the unmistakable thud of the table leg as it hits ZAHID again and again.

Beat.

Sound of an alarm rings out.

Light on STEWART's eyes.

STEWART: [*] Me cellmate's had an accident guv. **[V1]**

Prison Officer NICHOLSON steps forward.

NICHOLSON: *(Strong Scottish accent.)* [*] Malcom Nicholson. At the time of the attack on Mr Mubarek I was an OSG working permanent nights. On the night of the attack on Mr Mubarek I was on duty on Swallow Unit. At about 0345 hours a cell bell rang. That isn't unusual. They want toilet paper. Normally get up there and they want toilet paper so you have to go back down. Picked up some toilet

paper and went up. Went up to the door and opened the flap. [**V1**]

STEWART: Me cellmate's had an accident guv.

NICHOLSON approaches the cell now with toilet paper in his hand. He looks through the flap.

STEWART is standing in the cell holding the table leg. ZAHID is still lying in bed. NICHOLSON backs off and quickly exits, leaving STEWART standing there over ZAHID. We hear the sound of radio requests being made – progressively sounding more and more urgent.

RADIO: [*] Oscar 2 to attend Swallow Unit. Novembers 3, 4 & 5 to respond to Swallow Unit. All available staff to attend Swallow Unit immediately. [**V1**]

FELTHAM PO 2: *(Off.)* Open cell 38.

STEWART remains calm in his cell. ZAHID does not move. It takes a long time but eventually NICHOLSON and a second PRISON OFFICER arrive.

FELTHAM PO 2 opens the door.

FELTHAM PO 2: Drop the stick. Drop the stick Stewart. Now. Do it now.

STEWART drops the table leg. It is covered with blood.

Your back against the wall. Against the wall.

STEWART does as he is told.

NICHOLSON and FELTHAM PO 2 enter the cell and look at ZAHID. They both look horrified.

FELTHAM PO 2: *(To STEWART.)* What have you done?

STEWART: It was an accident.

FELTHAM PO 2: *(Horrified.)* What have you done?

STEWART: [*] It was an accident guv. [**V1**]

NICHOLSON takes STEWART out of the cell and puts him against the wall. Both PRISON OFFICERS go into the cell and peer at ZAHID.

NICHOLSON: Shit, look at his face. Looks really bad. Mubarek!

FELTHAM PO 2: Shit. Shit…better call an ambulance. Where's Nurse Berry? Mubarek! Can you hear me?

An Asian female Prison Officer – RANDHAWA – turns up. There is a flurry of activity as the PRISON OFFICERS phone an ambulance. STEWART remains standing in there.

RANDHAWA: [*] Satwant Randhawa. At the time of the attack on Mr Mubarek, I was carrying out my night shift as a Night Patrol Support officer at Feltham YOI. I received the call to go to Swallow Unit around 0340am and I made my way there as swiftly as possible. As I proceeded into the right hand side of the unit I noticed a prisoner outside a cell, whom I subsequently discovered was Mr Stewart outside cell number 38. I looked at Stewart. He looked at me and looked straight through me. There was no emotion showing in his face. He was still stood quite calm he wasn't restrained. **[V1]**

Is he conscious?

FELTHAM PO 2: Aye.

RANDHAWA walks past STEWART and looks at him. FELTHAM PO 2 leads STEWART away into another cell, where he is locked in.

RANDHAWA enters cell 38 and stands close to ZAHID.

RANDHAWA: [*] Mr Mubarek you've been hurt and we've called the nurse. **[V1]**

As RANDHAWA stays by ZAHID she addresses the audience.

[*] As I walked into the cell I saw blood splattered on the left hand side of the cell wall and to the right of me I recall seeing a table leg which had been removed and covered in blood. I thought then that Mubarek had had a battering

with that. Mr Mubarek was underneath his bed clothes and was very well tucked in and it struck me just how neat and tidy the bed clothes had been made up with him in them.

Mr Mubarek was still alive and his breathing was laboured. He did not look distressed but looked to me as if he was more unaware of what had occurred than anything else. He lifted his hand to his ear where blood was seeping from and he was also bleeding from his nose and had blood upon his face. [V1]

She turns to ZAHID.

You'll be okay. The nurse is coming.

She turns to the audience again.

[*] At this stage I was in the cell with him trying to keep him calm and let him know that he was not on his own and that he had someone with him. I could also hear a gurgly noise where he was breathing. He was trying to lift himself, and he was trying to talk but was having difficulty and was incoherent and so I just tried to keep him calm before the nurse arrived. [V1]

She turns to ZAHID.

Lay back. Just lay back, we are trying to get the nurse to you.

FELTHAM PO 2 hands STEWART some clothes through the flap.

FELTHAM PO 2: Strip down and change into these. I need your clothes.

STEWART changes obediently.

RANDHAWA turns to the audience again.

RANDHAWA: [*] He lay back and laid down still. At that point I felt helpless as we do a basic first aid course as part of our initial training. We are not issued with disposable gloves and there are none available on the wing. We waited about

fifteen minutes for the nurse, which seemed like an eternity at the time. Obviously, with the injury, when I saw the actual injury on his forehead, the length of it, it looked like a really deep cut. Whilst waiting I kept talking to him to reassure him. When Nurse Berry eventually arrived, she tended to Mubarek and she held his hand and she started asking – 'Where's the ambulance?' The ambulance had already been called anyway. She said, 'We are losing him and he is going into shock, we need to raise his feet'. [V1]

STEWART hands his old clothes back through to FELTHAM PO 2 who puts them into a bag.

STEWART is calmly washing his hands of the blood in his cell. FELTHAM PO 2 watches him.

FELTHAM PO 2: He's washing his hands. He shouldn't be doing that, should he? Isn't that evidence?

NICHOLSON: Stewart, back against the wall, against the wall.

RANDHAWA: [*] The paramedics arrived and put Mr Mubarek on an oxygen feed and immediately took over the situation. We were moving at a very fast pace to get Mr Mubarek into the ambulance and then off to the hospital. Throughout this time the paramedics were clearly concerned about Mr Mubarek because they were saying, 'We're losing him'. I volunteered to go with the ambulance 'cos Mubarek was still in our custody.

ZAHID is taken out of the cell on a stretcher. STEWART then lies on his bed and goes to sleep.

We arrived at Ashford hospital and Mr Mubarek was taken into the emergency operating room whilst we remained outside. The whole emergency area was in utter mayhem desperately trying to save his life. We were then informed that Mr Mubarek was to be moved to a special head injury unit at another London hospital. Mr Skidmore and myself returned to HMP Feltham. [V1]

STEWART takes off his shoe and scrawls on the wall with his shoe.

STEWART: [*] MANCHESTER
JUST
KILLED
ME
PADMATE
[*Swastika symbol.*] RIP
OV
M1CR **[V wall of cell]**

SCENE 5

IMTIAZ and SURESH step forward.

IMTIAZ: [*] Seeing those prison officers, you get the
impression they've already sat around and decided on
what they're going to say. They just turn around and say 'I
don't remember…' That's what they all did, all of them 'I
don't remember, I don't remember…' They closed ranks.
The Inquiry actually found that there were records that
were lost – like the prison cell search records on Swallow
Unit when Zahid and Stewart were there. No one could
explain where these records had gone. I think it still
remains to be seen for us whether this has been a thorough
enough Inquiry. I've still got many questions. I would like
to have seen those prison officers cross-examined more
closely. **[V2a]**

SURESH: [*] The Inquiry has finished now. Justice Keith
has told me that he hopes to publish his report around
March this year and then deliver his recommendations to
the Home Secretary soon after. As for Gladiator Games
– there's no direct evidence to prove that it definitely
happened in this case but if you're asking me were those
prison officers aware Stewart was a racist? I can't honestly
see how they missed the signs. And I hope Justice Keith
will at least mention it.

I think the Inquiry will be very hard on Feltham as to the circumstances which led to Zahid's death – how his murder should have been prevented. Will they implicate anyone? I don't think so. Will they hold anyone responsible? No. I think the Home Office will say Zahid died in 2000 and since then the Prison Service has improved dramatically – blah, blah, blah. I don't think that the Home Secretary will agree with the recommendations – to clean the Prison Service up from bottom up. It'll be a partial success in the sense that we know much more than we ever did. For us, Zahid is much more than someone who died in a prison cell. We will never forget how he died but we want to remember him for his aspirations and what inspired him to live and I think if there is legacy on Zahid, it should be those hard-hitting structural changes in the Prison Service – a Prison Service that is more open and accountable. If we lived in pre-9/11 days we would see the recommendations being taken up. Post 9/11, I think we live in the dark days. I really believe that. Curtailment of civil liberties, for people white or black, will be serious. **[V2a]**

IMTIAZ: [*] I used to be in computing before and after this case kicked off I found it difficult to be going into work when there was another part of my life that was dedicated to something that was really, really important to me. People say I've changed.

SURESH: He used to go clubbing.

IMTIAZ smiles.

IMTIAZ: Yeah... I just wasn't motivated to be doing what I was doing then. There was a vacancy going here and Suresh knew I was interested in working in this place and he gave me a trial period, it was part-time initially and I did it and I think he's happy with my work here so far and, erm, yeah so here I am. I'm based at the Monitoring Group now. Knowing Zahid I think even though he was going through this patch in his life we were always confident that

he would come out – even if was through our efforts, we would get him through this. There was so much that he didn't tell his parents 'cos – I know that he didn't want to burden his mother with his problems or anything like that. **[V2a]**

SAJIDA enters.

SAJIDA: Zahid always used to sit around and tell jokes. He was always happy.

SURESH: [*] What we were told was that Zahid was charged with stealing six pounds' worth of razor blades and interfering with a car. The probation report makes it clear that he has a drugs problem and that he had a few other convictions for petty crimes – shop lifting – that sort of thing but – if you look at Stewart's convictions and see what happens to him and compare that with Zahid – totally different treatment of Stewart. At worst Zahid should have got a probation report, a community service and maybe a suspended sentence. **[V2a]**

SURESH exits.

SAJIDA: [*] He was very playful with his younger brothers. Always joking with them. Mostly in English. He was older. Four and a half years older. The twins were born in January 1985. **[V2c]**

IMTIAZ: [*] Apparently from the court *(Hesitates.)* …Tanzeel told me that when he was there – it was quite poignant looking back on it now – in hindsight because it was like when the Judge said 'take him down' or whatever, Zahid just turned round to his grandad and Tanzeel and said in Punjabi, *'Me jara ow'*, it was his way of saying, 'I'm going again'. He said just the expression on his face was, was, you know, er, it was like…they was never going to see him again. You know…er…

Long pause.

At the time, my nephew and my dad thought it was pretty much the way they deal with things here. And especially dad, he believes in the system. My father's point of view was look – he's going to the Young Offenders Institute – it's not a full-blown prison. They've got to have things in place to rehabilitate er… *(He laughs sadly.)* have things in place to sort them out so that they can lead a more productive life. Had we known this much *(Measures a speck with his fingers.)* of what Feltham was about, really, you know, it would have been different. It would have been different. I was in Holloway Prison a couple of weeks ago, a visit for the prison law course I'm doing and I met a prison officer there. He said to me, 'You look remarkably familiar', and so I told him my name. He put his arm around me and said: 'Look, I'm really, really sorry about what happened. I was working at Feltham at the time and I knew Zahid. He was a smashing lad.' This was just a couple of months ago – it really hit me.

He was very much loved – despite his problems. He was very much loved. **[V2a]**

IMTIAZ exits.

SAJIDA: [*] He would phone every day from the prison. Talk to the brothers, the grandparents. Ask them – what are you eating? He sent a birthday card to the brothers from the prison. He said he was worried, always worried. He just wanted to come home. He wanted to get out. He used to tell the grandfather to pray for him when he went to the Mosque on Fridays. I used to ask him how he was but he never really used to tell me. He would say he was okay but would normally ask after his brothers. I am sure he was avoiding telling me precisely how he felt or how he was coping to avoid upsetting me. **[V2c]**

AMIN enters.

AMIN: [*] We've come a long way from nothing.

We want to see things happen. Basically we wanted to know why it happened, how it happened and why they were sharing the same cell. You know if you see a guy with a tattoo, short haircut, you don't need to be a scientist to work out what he is.

We want to move on. [V2c]

SAJIDA: [*] But the memory will be alive all the time. He will never be forgotten. [V2c]

[*] When I go to bed I see him in front of me. [V3]

SAJIDA and AMIN step back.

ZAHID enters.

ZAHID: [*] Dear Mum and Dad,
How are you? I am fine now. How are Zahir and Shahid? They mean the world to me. Tell them not to turn out like me. I was always hanging around with the wrong people and f–king smoking drugs and that's what f–ked me up. Dad I knew I should've listened to you from the beginning. Dad when I get out I want you to get me a job.
And how are grandad and grandma? Tell them I love them. Dad, tell mum I have not forgotten about her and tell her I love her so much. Tell my mum not to worry. I am okay.
Love
Zahid. [V6c]

End.

Results of the Zahid Mubarek Inquiry

In June 2006, the report of the public inquiry, chaired by Mr Justice Keith, found a 'bewildering catalogue' of both individual and systemic shortcomings at Feltham. The inquiry uncovered a 'catastrophic breakdown in communication' between prisons regarding the history of Robert Stewart and the final report named nineteen staff who were judged to have been at fault.

The inquiry report made 88 recommendations covering risk assessment of mentally ill prisoners, sharing cells, information-sharing, prison staff training, and the disclosure of psychiatric reports by courts to prisons.

It also asked the Home Office to consider introducing the concept of 'institutional religious intolerance'.

'Treating prisoners with decency may not be a vote-winner,' concluded Mr Justice Keith.

'Societies are judged by the way they treat their prisoners, and if more resources are needed to ensure that our prisons are truly representative of the civilised society which we aspire to be, nothing less will do.'